IMAGES
of America

1968 FARMINGTON MINE DISASTER

ON THE COVER: The last three men come out from the depths of the Farmington Mine on the morning of November 20, 1968. They were rescued using a construction crane and a bucket from a nearby construction project. All three of the men in the bucket were among the men who were working the midnight "cateye shift," and they were the last three working in the mine that night to come out alive. In the bucket are Gary Martin (left), Bud Hillberry (right), and Charlie Crim (back to camera). (Photograph by Bob Campione.)

IMAGES of America
1968 FARMINGTON MINE DISASTER

Bob Campione

Henderson County Public Library

Copyright © 2016 by Bob Campione
ISBN 978-1-4671-2378-5

Published by Arcadia Publishing
Charleston, South Carolina

Printed in the United States of America

Library of Congress Control Number: 2016947309

For all general information, please contact Arcadia Publishing:
Telephone 843-853-2070
Fax 843-853-0044
E-mail sales@arcadiapublishing.com
For customer service and orders:
Toll-Free 1-888-313-2665

Visit us on the Internet at www.arcadiapublishing.com

This book is dedicated to the 78 men who perished in the Farmington No. 9 coal mine in November 1968 and all the other miners who gave their lives to dig the black rock from the earth. Without them, our nation would not have electricity to power our homes or our industries. Coal plays a vital role in the production of steel, and coal by-products are used in many pharmaceuticals, plastics, and other consumer goods. The families of the coal miner also play a tremendous part in supporting the men who mine the coal. Family members always lived in fear of their loved one someday not coming home from work. Many times, mothers and wives would hate to answer the phone near the end of their miner's shift for fear it was going to be bad news.

A personal dedication goes to my father, Angelo Campione, for his devotion to his family and working 40 years underground to support us. He never complained about his work and made sure we had a good home and an opportunity of getting an education so my brother and I would not have to endure working in the coal industry. His life was shortened likely from the results of mining underground, as he died at age 68, only four years after he retired.

Contents

Acknowledgments		6
Introduction		7
1.	Miners' Families	9
2.	News Media Coverage	35
3.	Rescue and Recovery	59
4.	Life Continues	91
Miners Lost to the 1968 Farmington Mine Disaster		125
Survivors of the 1968 Farmington Mine Disaster		126
"The Mannington Mine Disaster"		127

Acknowledgments

This book is a product of many sources of information, starting with the newspaper accounts written by one of the most competent editors of the time, William Dent "Bill" Evans of the *Fairmont Times*. The depth of his knowledge on coal mining was a major factor in getting all the facts correct in his writing about this disaster.

Many thanks also go to Bonnie E. Stewart for her investigative reporting and publishing of her book *No.9–The 1968 Farmington Mine Disaster*. She uncovered many facts that were buried in files for years, and she researched many areas that were locked away from the public.

Thanks go to all who responded on social media with help identifying many of the faces in the photographs: Anthony Pulice, Janet Lieving, Bill Rice, Ron Crites, and Olive Marie Utt.

Many thanks go to my wife, Andrea Campione, for her encouragement and proofreading skills. Without her, I am not sure it would have been completed.

Unless otherwise noted, all images appear courtesy of the author's collection.

INTRODUCTION

The morning of November 20, 1968, started with a phone call around 6:30 a.m. at the Campione household. Sarah Campione answered the phone and was asked by the editor of the *Fairmont Times*, Bill Evans, if she would get her son Bob to come to the phone. Bob Campione, age 20, had been the photographer for the *Times* during high school and college up until his final semester, but he had to resign his full-time position while taking education classes at Fairmont State College that semester. The young photographer came to the phone, and Evans explained that there had been an explosion at the Farmington No. 9 mine and was requesting he come pick him up and go with him to photograph the incident. Campione requested he call his replacement because of his class schedule, but Evans insisted he needed him to go because of his experience and the magnitude of the situation. At this time, Campione was not officially employed by the newspaper; he was considered to be a freelance photographer and would be paid for any photographs used in publication.

The young photographer dressed and picked up Evans at his home on the other side of town, and the two traveled to the mine. It was a cool November morning, and as they approached the small rural town of Farmington, it was apparent by the dark haze in the sky something evil had happened. They had to drive through the small community of Farmington on their way to meet up with federal and state mine inspectors at the mine's main tipple. The tipple was located a few miles north of the small community, and during that short drive to the tipple, no words were spoken in the car. The uncertainty of what was around the next turn caused one's mind to speculate various scenarios of what might be encountered.

As they rounded the final turn with the Farmington No. 9 (Consolidation Coal Company, also known as Consol) in sight, nothing seemed to be amiss here, to their surprise. As they pulled into the parking lot of the Champion company store, directly across the road from the main tipple, there were already several other cars in the lot. Some of them had federal license plates, and others had official state tags. When Campione and Evans got out of the vehicle, they were greeted by a couple of the men dressed in mining clothes. These were the federal mine inspectors that had called Bill Evans in the early hours of the morning to inform him of the incident. Evans had become somewhat of an authority in covering mining accidents and explosions, so the inspectors knew he would be able to report clearly and factually the events about to unfold.

After a briefing from the mining inspectors, Campione got back in his car and began the drive to the Llewellyn portal. The drive seemed to take forever as thoughts raced through his mind. He could see in the distance a black column of smoke and continued his drive in that direction. As he went up the small, twisting country road, the column of smoke became more intense, and rounding the final curve, he saw the smoke-engulfed elevator structure and bathhouse where the miners would dress for work and shower after work before going home. Getting out of his car, Campione could smell the pungent odors being produced from the fire deep underground. He recognized the man trip elevator structure because as a small child he would go with his father, a coal miner, to the Grant Town mine where his father worked, to pick up his paycheck.

Climbing up a small embankment across the road from the structure, Campione leaned against a large oak tree and collected his thoughts. Checking the settings on his camera and using the tree as a support, he shot his first picture of the day. While he was standing there and looking at all the cars in the parking lot, one vehicle caught his eye. He recognized the car belonging to a friend's father. He had been in this car many times while riding to East Fairmont High School with him and his son. Suddenly, the magnitude of the situation took on a more personal impact.

As Campione was driving back to the main tipple to reconnect with Evans, his thoughts raced back to a time when he got to the newspaper office and Evans told him they needed to go report on a mine incident. Evans would not tell him which mine they were going to, but only to drive in the direction south of Fairmont. There were several mines in that direction Campione knew of, and as they approached Barrickville, Evans instructed him to turn in that direction. Making the turn toward Barrickville, Campione asked again which mine they were going to, and Evans finally told him it was Grant Town. That time of day, around 3:30 p.m., Campione's dad would be in the mine. The trip to the bathhouse suddenly seemed like an eternity. Reaching the parking lot of the mine, the two men went into the area where the miners would enter the elevator leading into the mine. The young photographer knew to check the board near the entry to the elevator to see if his dad's check tag was on the In side or the Out side of the board. His father's tag number 703 was on the In side of the board, which meant his father was still in the mine. Young Campione stood there frozen and afraid to ask any questions, fearing the worst. Suddenly, a miner still in his dirty mine clothes approached and asked him, "Are you Angelo's son?"—to which he replied yes. The miner informed him that his dad was on the next trip of miners coming out of the mine and that everyone was safe. This was a huge relief to the young man as he waited to see the man trip elevator door open and see his dad's dirty face. His father's check tag still sits on Bob Campione's dresser to this day, along with a pocket watch, to remind him of his father's life as a miner.

Coming out of his recollection and going back to the Champion store, Campione was told that several of the miners were being extracted at another portal. Campione was unfamiliar with all the back roads of the area, and a local man offered to take him to the Mahan Run shaft. The two started driving through the back roads of West Virginia, down through the countryside where many of the miners may have lived. Arriving at the portal, Campione grabbed his camera and walked up a slight embankment to the side of a large cement shaft that led into the depths of the mine. There were a few men there working and some medical personnel standing by to help the men being extracted from the large bucket that had been lowered several hundred feet below the surface into the mine. Several of the men who were brought out of the mine at this location had already been transported to a local hospital. Listening to the men talk, Campione understood that those coming up this trip were the last ones at this location. The young photographer stood beside the cement curb of the shaft that rose about four feet from the ground. Again, he adjusted his camera, using his best judgment as to what exposure setting would be best to get this once-in-a-lifetime shot. The metal cable was slowly and constantly moving upward, but there was nothing but darkness when he looked down the square shaft. One of the men commented that the cable was moving only a few feet per minute in order to stabilize the rescue bucket. After what seemed like hours but was actually only minutes, Campione could see the top pulley of the bucket coming from that dark shaft. Carefully steadying his elbows on the curb, he focused the camera and took his first shot and then another. Suddenly, the bucket stopped rising. The metal cable had become twisted, and the men were suspended just about 15 feet short from the top of the shaft and being rescued. Gary Martin, one of the miners in the bucket, grabbed the cable in an attempt to get it going again, but with no luck, as the cable had become tangled with the weight of the men and bucket. He was not able to free it. Bud Hillberry, another miner in the bucket, told the men above to tell the crane operator to raise the crane boom to lift them the remainder of the way. The operator complied, and the three miners were now safely out of harm's way. Campione got back into his car and headed to meet up with Evans at the company store. Once arriving there, he informed his editor he was going back to the paper office and process the film to see if his shots were successful.

The approximately 10-mile trip back to the newspaper office seemed to take forever as Campione wondered how his shots would turn out for this rescue. This began the photographic journey he would travel for the next 10 days as he recorded the history of this major mining disaster that would change the future of mining safety.

One

Miners' Families

It was near the end of the midnight cateye shift, around 5:30 a.m., when the first explosion took place near the Llewellyn portal and then three more before an explosion took place at the Mod's Run shaft, causing a massive fire. Telephones rang as family members passed on the news of the explosion and subsequent danger to loved ones possibly in the mine that morning. Radio stations interrupted their programming to make announcements of this catastrophic event. For some family members, this was how they found out about the tragedy. Some of the miners' children were away attending colleges and universities and also heard about the disaster in this manner.

The Farmington No. 9 mine disaster of November 20, 1968, was viewed around the world by people as a catastrophic mining accident. The families of all 78 men still in the mine that morning looked at it from another perspective. They felt the personal impacts on their lives and prayed that it was going to go away. The Champion company store located across the street from the main tipple of the mine became the gathering place for the family members and a handful of press that November morning. Hope was high that the men in the mine would find a safe way out or at least find safe shelter in the mine where they could wait for a rescue team to locate them and bring them out to safety. As the day wore on, more family members and other members of the community crowded the small company store. The number of news personnel continued to grow throughout the day, as it was becoming apparent this was going to be a major newsworthy event.

The company store was a place that provided dry goods for the miners and their families. It was like a general store of sorts and served the families of the small community. At that time, some of the miners were still paid in company script. Miners paid with script could only use the company store because the coins held no value outside of company-operated enterprises. The number of news journalist kept growing throughout the day and even into the night. By the next morning, it was clear this was going to be a major news event, as television crews arrived and more demands were made to have access to a telephone. It was not long before the phone company arrived to install additional phone lines to help support the requests of the news media. The telephone was the main communication link at that time to transmit voice and sometimes data to respective news affiliates.

On the second day of what was to become an 11-day nightmare, the small building was divided so families could have a little privacy. The rear of the small store was where the overstock was kept and that area became the media headquarters for the next few days. Film cameras soon filled the room, along with television cameras and microphones, to cover the tragic event. The families occupied mainly the front of the store, or the main sales area. News briefings took place in a makeshift area set up so mining officials, union personnel, and others could deliver any new information about the progress being made to rescue the men trapped underground.

Tensions would build between the families and the news media as the families felt their privacy was being invaded. It did not take long before the local news staff was in the minority and news personnel from around the nation and even the world started flooding the small community. The Associated Press, United Press International, the BBC, and many television stations from the Pittsburgh market were among just a few of the many media individuals wanting to cover this story. It was becoming apparent that the little Champion store was never meant to accommodate this type of activity. Working together, mining officials from Consol and United Mine Workers of America (UMWA) decided it would be best to separate the families from the news media. The small church located across the street and within view of the tipple became the safe haven for the families. A business location in the main part of Farmington would become the home for the news media for the remainder of the incident.

On November 21, 1968, the names of the survivors were published in the local newspapers. They are Roy Wilson, George Wilson*, Lewis Lake*, Ralph Starkey, Gary Martin*, Charlie Crim*, Neezer Vandergrift*, Raymond Parker, Robert Parker, Robert Mullins, James Herron, Paul Sabo, Nick Kose, Robert Bland, Waitman "Bud" Hillberry*, Nathaniel Stevens, Walter Slavekosky, Charles Beafore, Byron Jones, Henry Conaway, and Matt Meanas Jr. (An asterisk denotes the men rescued at the Mahan Run portal via the rescue bucket and crane. The other miners were able to escape the disaster by walking out of the mine at the main tipple slope. The miners who came out of the mine via the slope were in the section used to haul coal from the mine. This area was well coated with pulverized lime known as rock dust. Rock-dusting the interior walls of a mine reduces the amount of coal dust, hence decreasing the source of combustible material.)

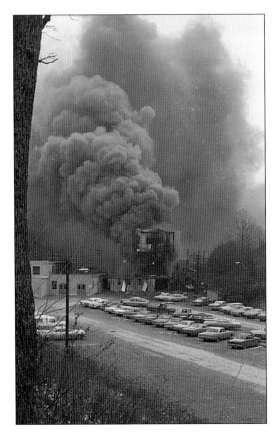

LLEWELLYN PORTAL SMOKE. As smoke pours from the recently opened portal at the Farmington Mine, cars sit in the parking lot awaiting the return of their owners working the cateye shift. The men reported to work on the night of November 19, 1968, and began their shift at midnight on November 20, 1968. Seventy-eight of those men who reported to work on that shift never returned to drive home the next day. There were 21 men who did survive the blast. Some were close enough to the slope and walked out, and eight others were removed by bucket at Mahan Run shaft.

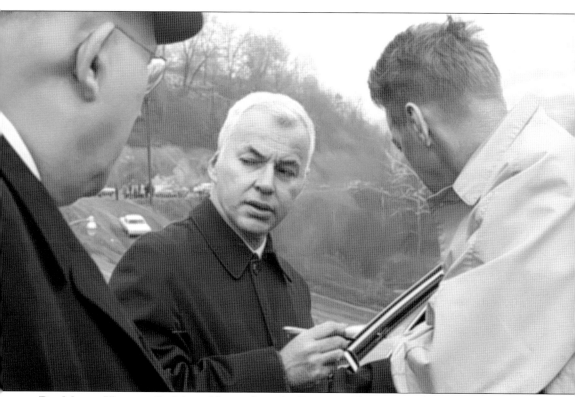

DR. MURRY HUNTER. Dr. Murry Hunter from the Fairmont Clinic was at the Mahan Run portal directing a staff of medical personnel as the men were rescued from the mine. Five of the men rescued were transported by ambulance to Fairmont General Hospital for treatment. By that evening, the hospital reported that those five miners were in good condition.

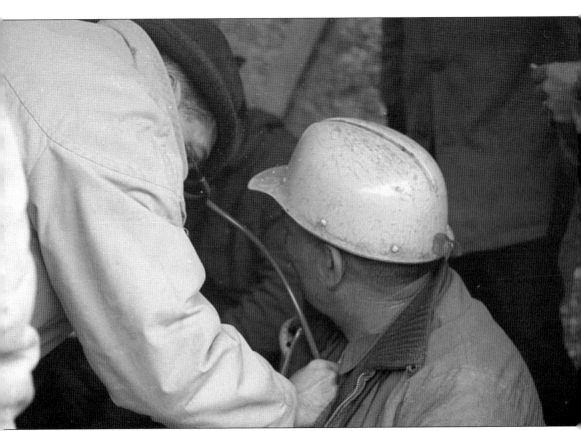

RESCUED MINER EXAMINED. One of the eight miners rescued at the Mahan Run portal is being examined by a doctor who came there to assist with rescue operations. Dr. Stillings from Mannington and Dr. Hunter from Fairmont treated many of the miners and family members.

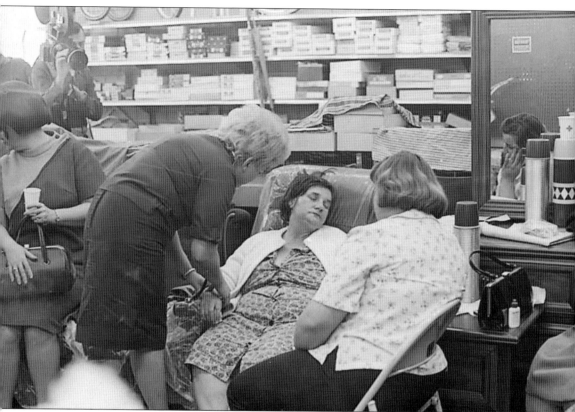

CHAMPION STORE. The Champion store, located across the street from the Farmington No. 9 Main plant, was the site for families, news media, and officials to gather on the first day of the blast. The store quickly became very overcrowded with the flock of concerned people using this small facility. A news media center was setup in the town of Farmington to help separate the families from all the attention. The small church just across the street was then used for families to find a refuge.

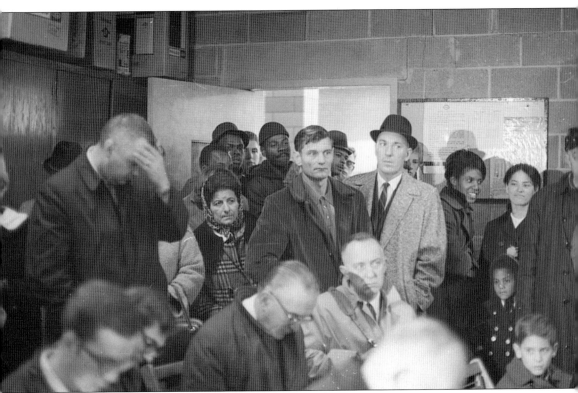

CLOSE QUARTERS. By the morning of the second day, the Champion store's back room was becoming very crowded with family members, the curious, and the news media all huddling into the small space. There were times when one could hardly hear because of the poor acoustics and the low tone of personal conversations taking place.

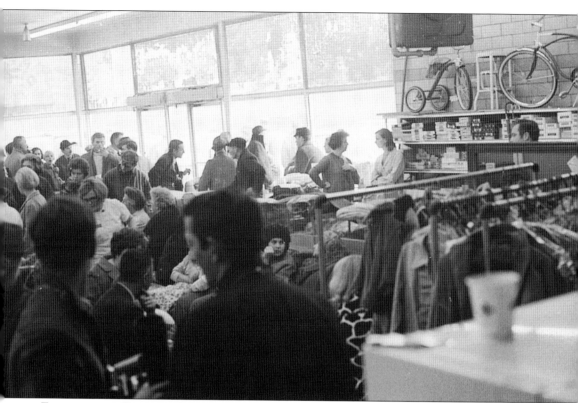

FAMILIES INSIDE CHAMPION STORE. One could only imagine the thoughts running through the minds of the families while standing in the company store stocked with holiday presents. Thanksgiving was just days away at this time, but no one was in a very festive mood. Their only thoughts were for the safety of the miners still underground—approximately 600 feet below them—and hoping they might have found shelter somewhere in the darkness.

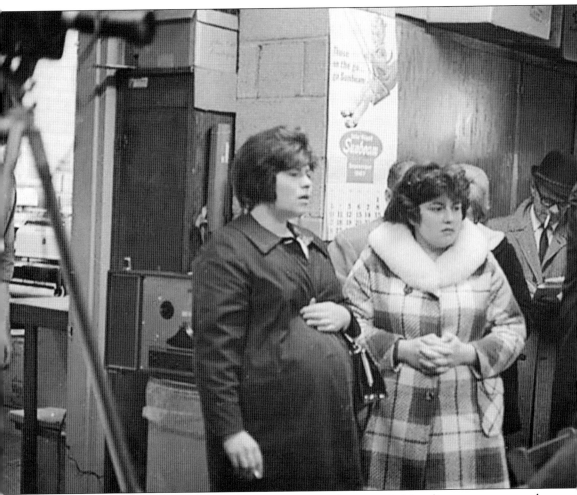

LADIES. Because this was a small mining community, the extended families were strong and helped support each other in many ways. This disaster brought these families even closer together as they comforted each other while waiting for news about the husbands, fathers, and sons still unaccounted for. Barbara Toler was pregnant with her third child, and her husband, Dennis, was among the miners still in the mine. She gave birth three weeks after the explosion to a son who never got to know his father.

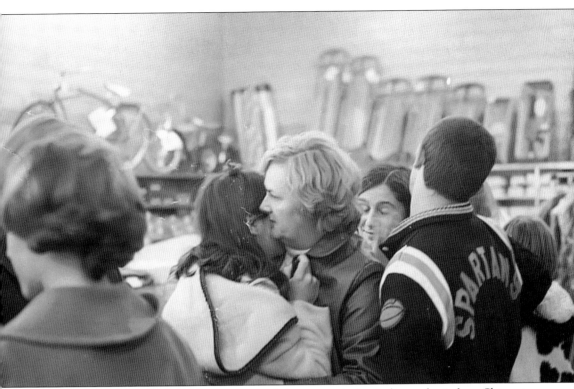

SHINNSTON HIGH SCHOOL. The young man's letterman jacket indicates he is from Shinnston High School, located in Shinnston, West Virginia, approximately 10 miles south of Farmington. Many of the miners working in the Farmington Mine traveled from small towns and cities daily to get to work. Mining was a common way of making a living in West Virginia.

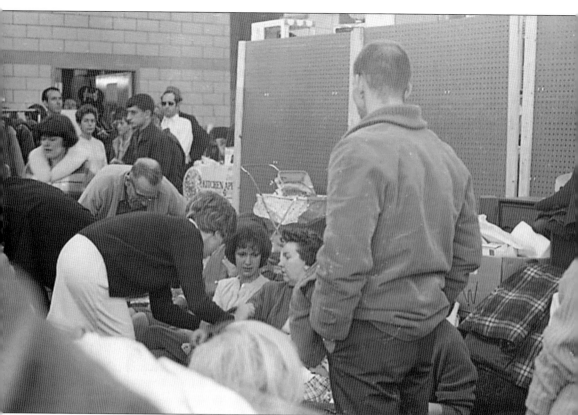

AID TO VICTIMS' FAMILIES. The stress of such a situation called for help from outside the immediate community. Doctors and nurses from around the state came to assist families and individuals by administering counseling and basic medical needs. Along with the Salvation Army and American Red Cross, these folks are assisting in any manner they can.

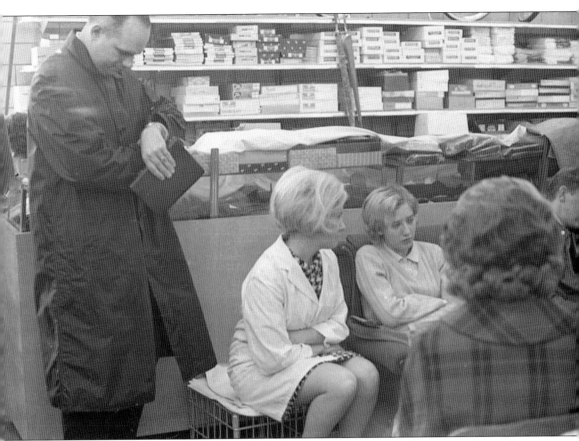

TIME PASSES. A man looks at his watch as seconds lead to minutes and minutes to hours during the first day. Everyone knew that each second the miners were still underground, their chances for survival diminished. Strong support for each other and their faith in God were the threads of hope people clung to as they received more announcements of further explosions inside the mine. No one, on this first day, could imagine the seconds ticking would lead to days before the mine would be sealed along with the 78 miners still inside.

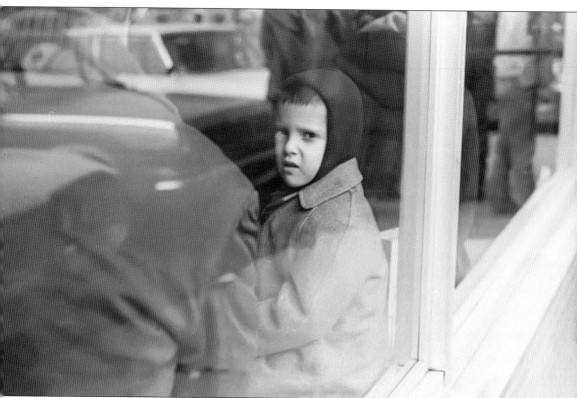

Young Boy Waiting, Champion Store. This young boy, a son of one of the miners trapped underground, does understand the magnitude of what was taking place that early November morning. Because so many miners lived in and around Farmington, Mannington, and neighboring communities, 12 of the local schools closed, showing care for the families of the miners. This boy's father would never get to see his son grow up, nor would this young person get to have the support of his dad.

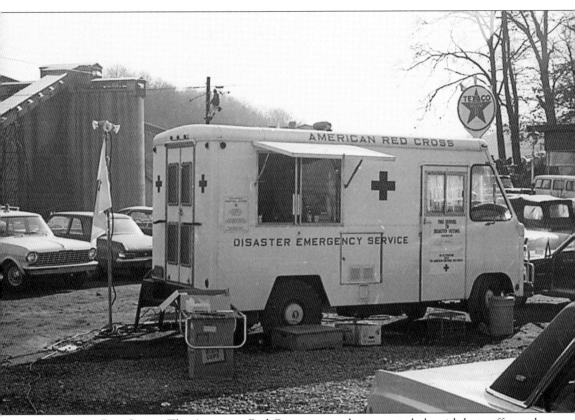

AMERICAN RED CROSS. The American Red Cross was on the scene to help with hot coffee and food for families awaiting news about the men trapped below the earth's surface. Day and night, the Red Cross van was there, with personnel passing out food and words of encouragement to people from the community. Members of the news media were also welcome to get hot coffee or a sandwich because the nearest restaurant or store was miles away. The small Champion store sold only dry goods, no prepared food.

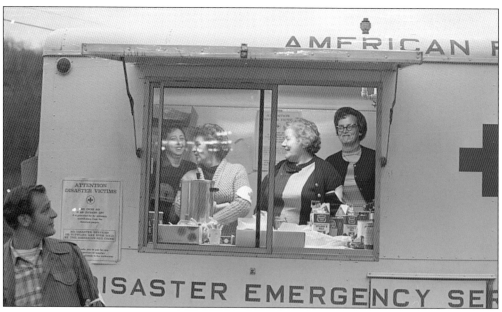

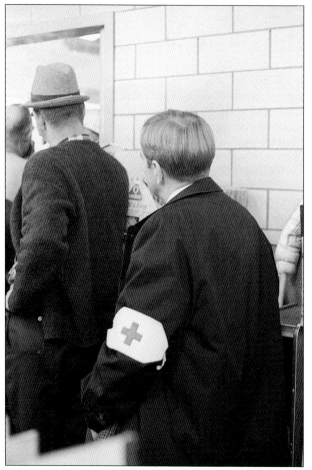

AMERICAN RED CROSS AND SALVATION ARMY. The American Red Cross from Fairmont dispatched the mobile disaster unit under the supervision of Mary Edith Bell, executive secretary, and David Daniels, chapter president. The Salvation Army and the James Fork United Methodist Church volunteers helped staff the unit and made coffee and sandwiches for rescue workers, family members, and officials.

VIGIL AT PLANT. Families stood watch across the street from the Champion store and observe activities taking place at the Farmington No. 9 plant tipple, hoping for a sign of something good. The main tipple was located on State Route 218, a couple of miles north of the small town of Farmington. Because it was a main highway, it was not closed to public use. Other portals to the mine were in remote areas, and the roads to them were closed to the general public by state police and National Guardsmen. The community had become a hub for the curious, as well as the news media, so police and National Guard units were used around the clock to help keep the area secure and safe.

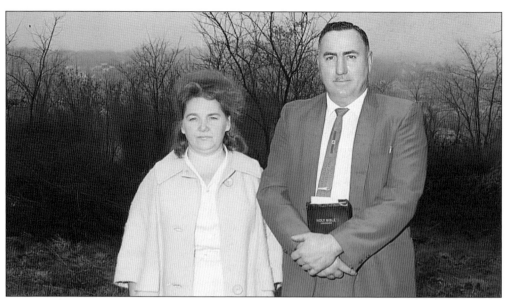

ROY WILSON. Roy Wilson, a mine foreman, was working with his crew at A Face when he felt something was very wrong. He called the dispatcher and was told by the person answering the phone to get his men out of the mine as quickly as possible. Roy took his men to the slope leading out of the main tipple. They all walked out safely about 7:00 a.m. Roy was also a minister and did weekly radio broadcasts from a local Fairmont radio station. He felt that the divine protection of the Lord saved him during wartime and also at this time in his life. Seen here with his wife, Mick Wilson, Roy continued broadcasting into the later years of his life.

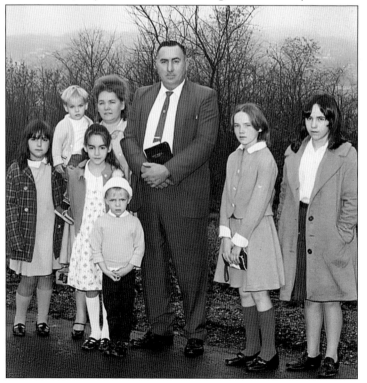

THE WILSON FAMILY. This family photograph of the Wilsons was taken weeks after the disaster. Pictured are, from left to right, (first row) Sharon (Core), Crystal, Timothy, Roy (father), Kimberly Faye (Cork), and April (Potts); (second row) Terry David and Mick Wilson (mother). The family was very grateful that George Wilson, Roy's brother, was rescued from the inferno that November day in 1968. He later went to work at another Consol mine, Loveridge Mine, located near Morgantown, West Virginia, where he finished his mining career.

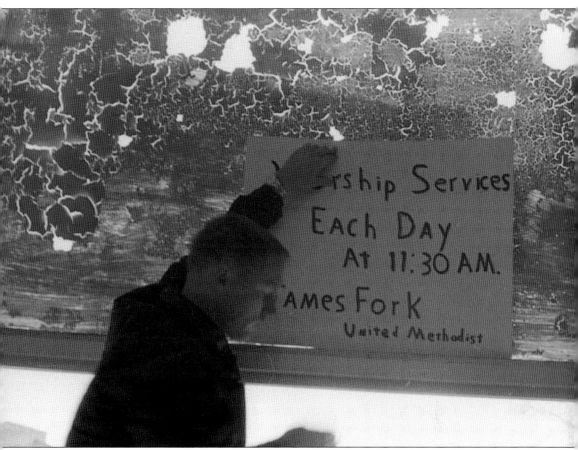

WORSHIP SERVICES. A notice was placed up at the Champion store letting family members know about the worship services being held at the James Fork United Methodist Church. The church was a safe haven for family and friends of the trapped miners. No press was ever permitted to go to the church, so any photographs were taken from a distance with telephoto lenses.

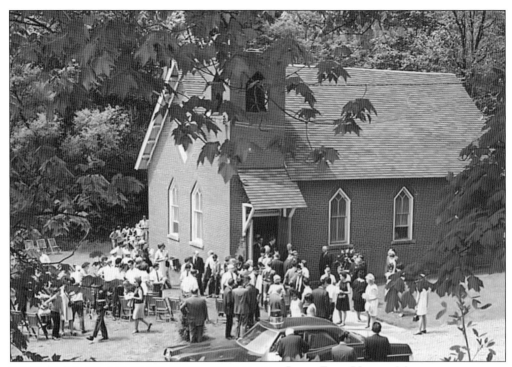

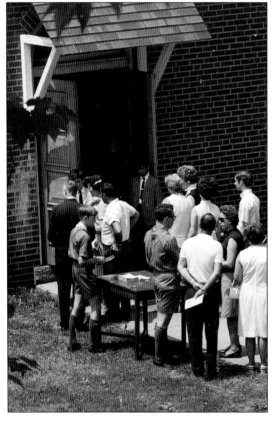

JAMES FORK UNITED METHODIST CHURCH. The James Fork United Methodist Church, located in proximity to the Champion store and the Farmington No. 9 Main Plant, is where most families found comfort from all the attention and awaited news about their loved ones. There was also a small trailer set up adjacent to the church that housed Consolidation Coal Company personnel who were counseling family members.

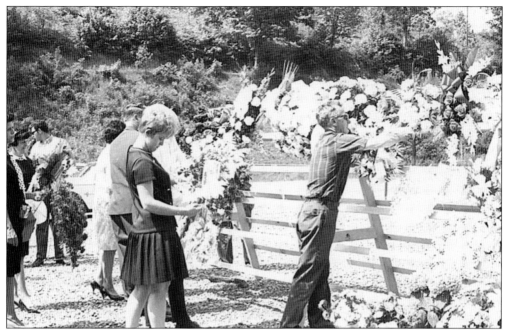

WREATHS. A memorial service was held at James Fork United Methodist Church. After the service, families placed wreaths on a rack outside of the church. The church was off limits to outsiders and members of the news media. It was solely for the families to find refuge from all the attention the community was being given and to help them deal with this tragedy in their own spiritual manner.

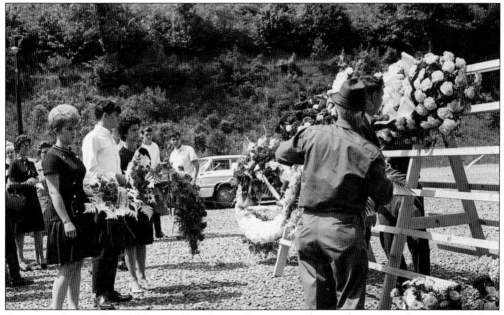

AWAITING LOVED ONES' NAMES. Family members patiently stood awaiting the names of their loved ones to be called, so they could place a wreath on the specially built wooden frame; each wreath represented a trapped miner. Hope was dimming, but the families were still clinging to a small chance their loved ones might still be alive.

A. James Manchin. A. James Manchin entered politics in 1948 at age 21 and was elected to the West Virginia House of Delegates. In 1961, Pres. John F. Kennedy appointed him state director of the Farmers Home Administration, and he held this position until 1971. Manchin lived just outside the town of Farmington on US Route 250 and was a strong supporter of the coal miners in the area. He was an orator and could deliver a moving sermon—and did so many times in his career. The lady to Manchin's left is Sara Kaznoski, who helped form the Widow Mine Disaster Committee, which supported the widows and made sure their loved one's bodies would be recovered.

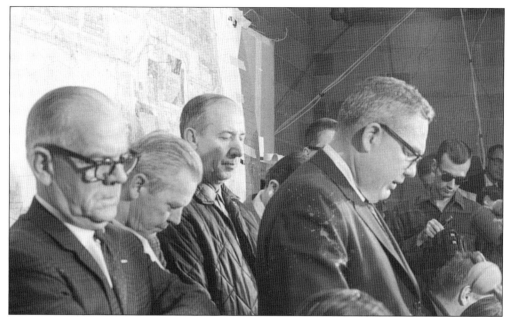

MOMENT FOR PRAYER. The executive vice president of Consol, William Poundstone, took a moment and asked everyone to say a prayer for the miners that had not made it out of the mine. The church was not the only place where people paused to ask for guidance from a more powerful being. Asking God's help in watching over the miners and the rescue teams trying to reach them was on everyone's mind that day.

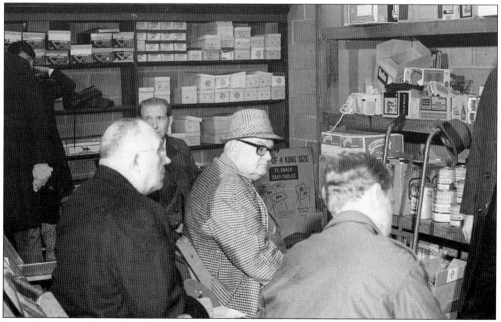

BACK ROOM OF CHAMPION STORE. Along with a couple of other reporters, Bill Evans (center, in hat and glasses) sits in the back room of the Champion store on day one of the explosion. Later in the day, the shelving would be covered with maps of the mine interior and other materials so officials could explain to the media what was being done to try and rescue the trapped miners.

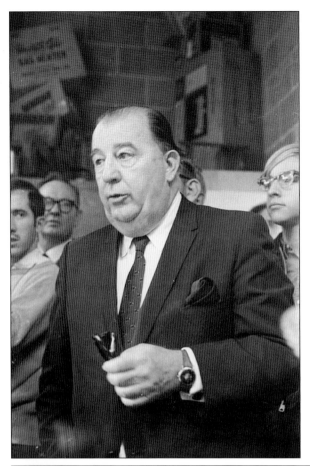

JENNINGS RANDOLPH, UNITED STATES SENATOR. Sen. Jennings Randolph, at left, spent several days at the mine site talking with families, mining officials, and the press. He grew up in Salem, West Virginia, in coal mining country, and knew about mining and the men who mined coal. Bill Evans and Senator Randolph are seen below talking over the tragic event. Evans is helping Randolph better understand how the events of the incident are unfolding and some of the major concerns facing recovery of the trapped miners. Senator Randolph mingled among the family members at the Champion store, lending his support for their loved ones safety. He later was an advocate for future legislation to improve mine safety. His dedication to the miners and their families throughout this time was important in helping the US Senate understand how necessary it was to improve the working conditions for all mining sites across the nation.

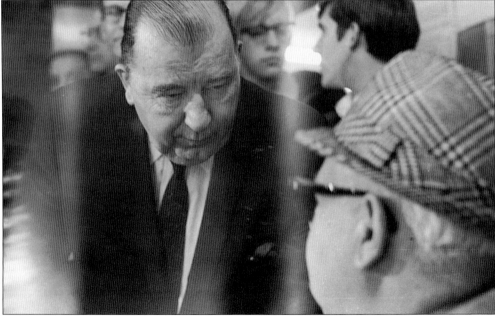

THE JOHNSON FAMILY. Percy Johnson (left) and his family lived in Star City, West Virginia, just outside of Morgantown. He was working at the Farmington Mine as a foreman at the time of the disaster. His daughter Dianne Johnson (center) and his wife, Virginia Johnson (right), represent a typical mining family in that era. Many people were trying to portray miners and their families in West Virginia as living in shacks and poverty. In 1968, the average union miner was making approximately $30 to $35 per hour, depending on their job responsibilities. Mine foremen worked for the company and were paid a salary that was slightly above the union miner's wages.

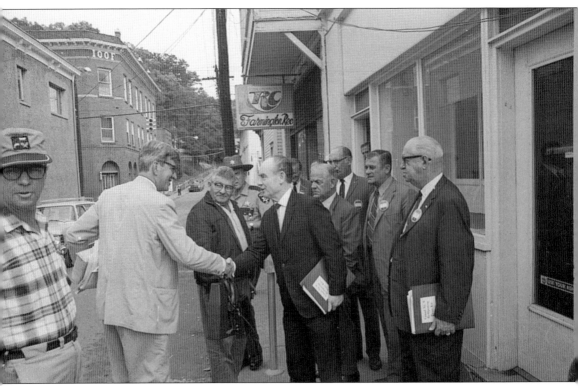

Boyle Greets Family. UMWA president William Anthony "Tony" Boyle greets family members coming to the meeting at the Farmington Town Hall to hear Consolidation Coal Company's plan for recovering the bodies of their loved ones. The families were very anxious to hear from the company and to make sure the mine did not reopen for coal production until all the bodies had been accounted for. Many of the families were skeptical but felt the UMWA would help ensure that the company would take the right approach in recovering the bodies.

DAY 11, LAST MEETING. Family members of the trapped miners enter the Farmington Town Hall for what was to be the last meeting after 11 long days. The news media had already been told earlier in the day that there was little chance of survival for the 78 miners after being trapped underground for 10 days with no fresh air and high readings of methane gas; the only option left was to seal the mine. This would eliminate oxygen from a fire triangle equation and prevent any further explosions. Three things are needed to have a fire triangle equation: combustible material, in this case coal and coal dust; heat, which could possibly cause a spark to ignite the methane gas; and oxygen to support combustion. It was not possible to remove two of the elements, so this left no choice but to take away the one element men had control over, and that was the oxygen. Eventually, fire would no longer be a threat.

FARMINGTON TOWN HALL MEETINGS. Family members are seen here exiting the Farmington Town Hall after being given the news that the mine would reopen and recovery of their loved ones would begin. Little was said as they exited the building; the mood was very somber. Many of their lives had been put on hold the past 10 months as they waited for this news to come.

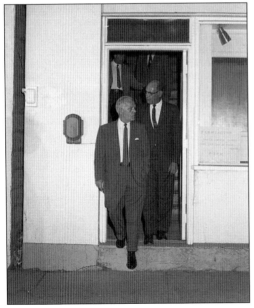

EVENS AND FERRETTI LEAVING TOWN HALL. Lewis L. Evans (left), UMWA safety director, and Peter P. Ferretti, vice president of Consolidation Coal Company, are seen leaving Farmington Town Hall after all the sessions of the day were finished. It would now be the position of the union to see that the recovery operation was progressing and that the bodies of the 78 entombed miners were recovered. It is doubtful that anyone at this time would realize it would be 10 years before this recovery operation would be completed and the mine sealed for eternity, along with 19 unrecovered bodies.

Two

News Media Coverage

The concussion was felt as far away as A Face, on the eastern end of the mine, where a production crew of seven men was working. They walked about a mile and a half to the slope where coal was hauled out by belt to the preparation plant and came up the long incline to safety. Two mechanics working in a motor barn near the Atha's Run portal rode its elevator to the surface, some two miles away from the slope, while four other men nearer the slope also reached it and came out unharmed.

Consolidation Coal Company's Farmington No. 9 coal mine was in the northern part of West Virginia, approximately 90 miles south of Pittsburgh, Pennsylvania. It was located in Marion County, about 10 miles north of Fairmont, the county seat and closest city. Like so many of the coal mines in West Virginia, the main coal mine plants were located in remote areas on the surface; however, the tunnels underground would reach many miles and sometimes be underneath cities. The Farmington Mine tunnels ran mostly northwest toward another small city, Mannington, about five miles north on US Route 250. The Llewellyn portal was located about two miles north of Mannington just off Route 250, which runs north to the city of Wheeling, West Virginia. Because of the remote location and hilly terrain, getting around to some of these locations was, at best, difficult. The first news reporters arriving at the scene were from Fairmont, Morgantown, and Clarksburg. These professionals knew about coal mining and understood the dangers the miners might be facing. The next wave of reporters came from larger news centers, like Pittsburgh, Pennsylvania, and Charleston, West Virginia. Pittsburgh television news channels were just starting to use helicopters to cover traffic and news in their local area. This event presented the perfect opportunity to use a helicopter. While most mining disasters present nothing to see from the surface, this one had a huge column of smoke rushing out of the ground at one of the portals.

A news helicopter was there about midmorning, filming the area around the Llewellyn portal; the footage would be aired on its television news programs that day. By midafternoon and into the evening, news vans with film crews started arriving in the small town of Farmington. It would be difficult to estimate the numbers, but it greatly increased the population of the community. Some of the big-city reporters were very much out of their element, and this caused many of the locals to resist talking with them.

By day three, all the major television networks were represented, along with the news syndicates and their photographers and film crews. There were even a few international news crews there to record the events, as well as freelance photographers on-site—all looking for that one special shot no one else had captured. It was this worldwide attention to one of the worst mining disasters to occur in modern times that would later lead to reforms in laws governing mine safety.

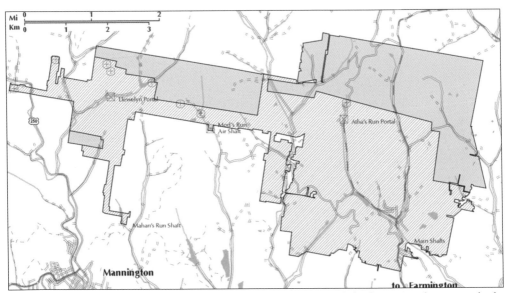

MAP OF MINE. This map shows Farmington No. 9 mine's size and the location of its mine shafts with a topography overlay. The light area represents the room and pillar section of the mine at the time of the disaster. The darker area represents the retreat mining area at that time. Room and pillar mining leaves pillars of coal behind, while retreat mining uses machinery that takes all of the coal and lets the top fall in after the men and equipment retreat from the area. (Map by Kashi Aminian, Lloyd English, Douglas Patchen, Hema Siriwardane, West Virginia University National Research Center for Coal and Energy, and Charles D. Estes.)

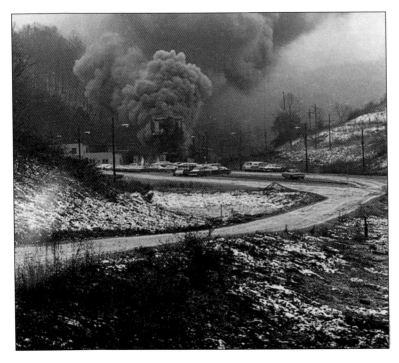

FIRST VIEW. A young photographer traveled up a small county road with no idea what he would find at the Llewellyn portal. Rounding the curve, he was met with this first sight of the structure and wondered if it would be safe to continue any closer. Leaving his car, he did venture closer and climbed up a bank on the left to get a better vantage point for taking more photographs of this horrific sight.

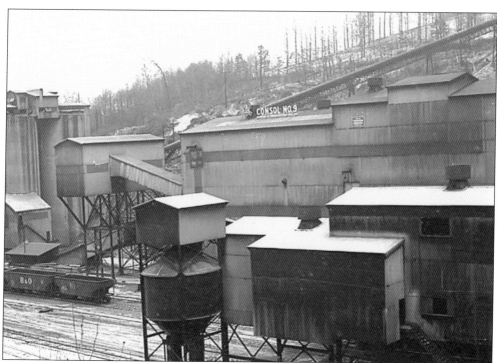

MAIN PLANT. The main plant was where coal was brought from deep underground and cleaned, sorted, and put on railcars for shipment to many of the power plants generating electricity for the country. This was also where the slope that some of the men used to walk out of the mine in the early-morning hours of November 20, 1968, was located.

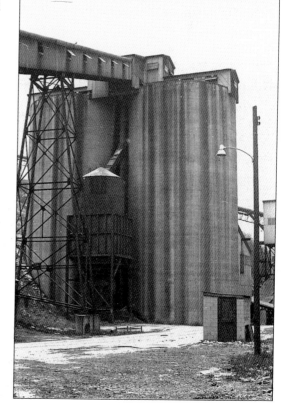

COAL SILOS. The coal silos located at the main tipple area of Farmington No. 9 mine were silent and never received any coal for storage again after the explosion. The coal silos had been used for temporary storing bins for the clean coal before it could be transferred out for transportation to a coal-fired electric power plant.

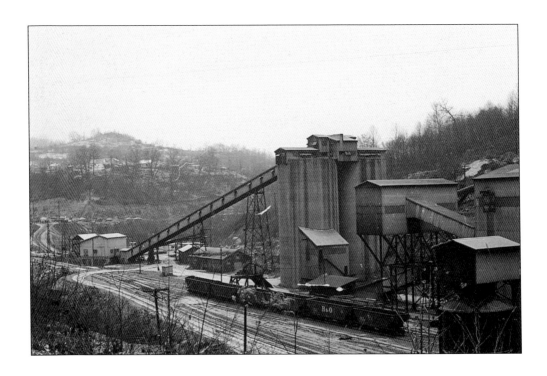

MAIN TIPPLE, FARMINGTON NO. 9 MINE. The main tipple of the mine is where the raw coal coming out of the ground was received and processed. Small railcars transported the coal from deep underground to the surface and into the main tipple, where it would be washed, cleaned, dried, and separated into various sizes for different applications according to the customer's request.

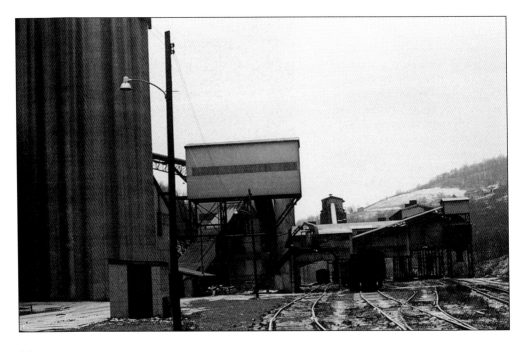

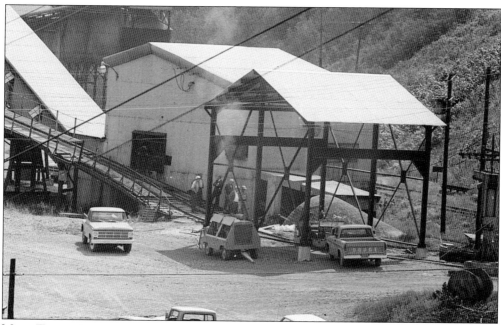

MAIN TIPPLE, FARMINGTON NO. 9 MINE. Before the days of automation in the mining industry, the coal was brought out of the ground using mules or horses. These animals were usually housed in the mines and seldom saw the light of day. However, they were well cared for because getting the coal to the surface was most important. At that time, the animals would pull small wooden carts with steel wheels traveling on steel tracks. This process was later modernized using small electric locomotives to pull much larger steel cars out of the mine. Today, there is no visible sign of the once large industrial complex used to process approximately 10,000 tons of coal on a daily basis. All of the structures have been demolished and the land taken over by Mother Nature. The penetrations into the ground have all been sealed, along with the remaining 19 bodies of the miners never recovered from the disaster.

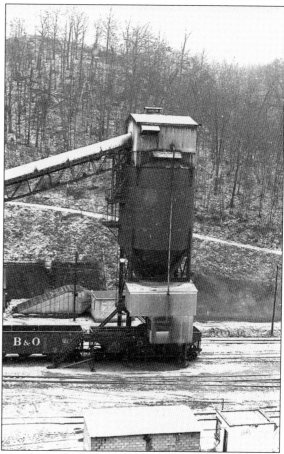

FAIRMONT TIMES PHOTOGRAPH. The November 21, 1968, *Fairmont Times* newspaper tells the story of the first day of the mining disaster in photographs and print. A *Fairmont Times* reporter and photographer were the first news media to be at the mine location that early November morning. Bill Evans, editor, and Bob Campione, photographer, were notified before word had been passed on to other news sources. In the days before the convenience of cell phones, the conventional telephone was the fastest way to communicate to the outside world. Because of the remote location, it took some time for the word to spread.

LOOK FROM TIPPLE AREA. Early on the morning of November 20, 1968, there was little or limited security at the mine site, so the news media, mostly local reporters and photographers, were not restricted as to where they could go. Once word had spread and more and more news media started flooding in, all mine areas were restricted to rescue and recovery personnel only. This photograph with a view looking up toward the Champion store was taken down by the main tipple.

CHAMPION STORE REAR LOT. The parking area behind the Champion store was an area where news media personnel would take a break and discuss the findings presented in the last briefing. Bill Evans is seen in the lot along with two other reporters as they gather their thoughts together before sending information off to their respective news offices.

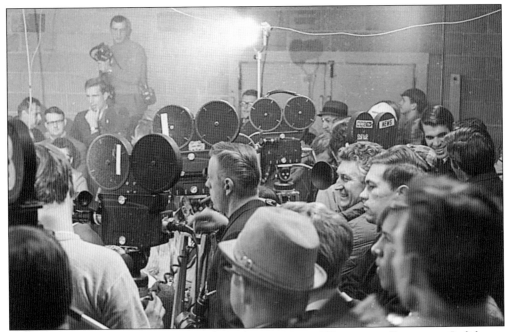

WORLDWIDE COVERAGE. It did not take long before news media from around the world descended on the small mining community of Farmington, West Virginia. The small Champion store soon became very overcrowded as news personnel convened there to cover this tragic event. All major American networks were represented along with all the wire services from around the world (note the BBC-TV News sticker on one of the cameras).

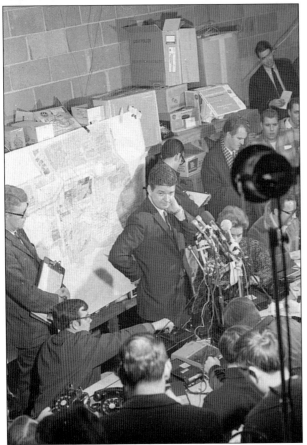

MAKESHIFT NEWSROOM. The Champion store, by default, became the makeshift newsroom because it was located across the street from the main tipple. It was easy to get to and from the town of Farmington on State Route 218, about two miles north of the town. With little time to plan, company officials brought in large maps of the mine and propped them against cardboard boxes in the stockroom of the store.

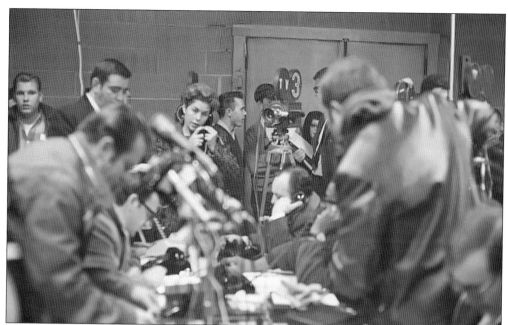

NEWS MEDIA. The storage room of the Champion store was very chaotic at times, especially following a news briefing from mining officials. The room was cramped with phones, television and news cameras, and news personnel vying for working space. Reporters from around the state, nation, and world came to this small community to cover this very tragic story.

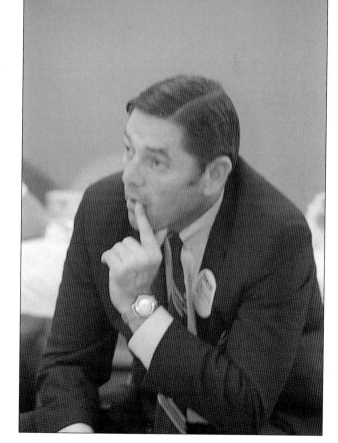

MCCARTNEY. James McCartney was the public relations director for Consol's West Virginia operations. He was only on this job for a very short time before he was put into the position of addressing news media and the public during one of this nation's worst mining disasters in modern times.

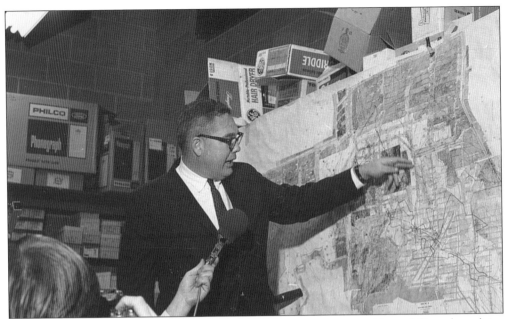

EXPLAINING THE MINE MAP. William Poundstone, executive vice president of Consol, explains the mine layout to the news media so they can get a better understanding of how large an area the mine covers. At the time of the disaster, Farmington Mine had approximately 22 miles of underground passageways. The mine employed 320 miners, and they mined approximately 10,000 tons of coal each day, around the clock, during three shifts. Poundstone also explained the various sections of the mine where miners were working at the time of the explosion.

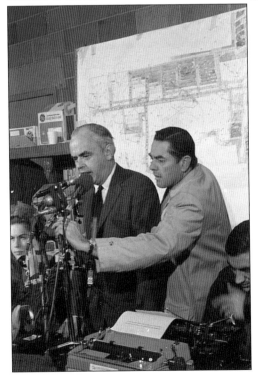

JOHN CORCORAN ADDRESSING GROUP. John Corcoran, president of the Consolidation Coal Company, prepares to address the news media and family members. James R. McCartney of Morgantown, director of personnel and public relations for Consol, assists by adjusting the tangle of microphones hastily attached to a single mike stand using black tape to hold them all in place.

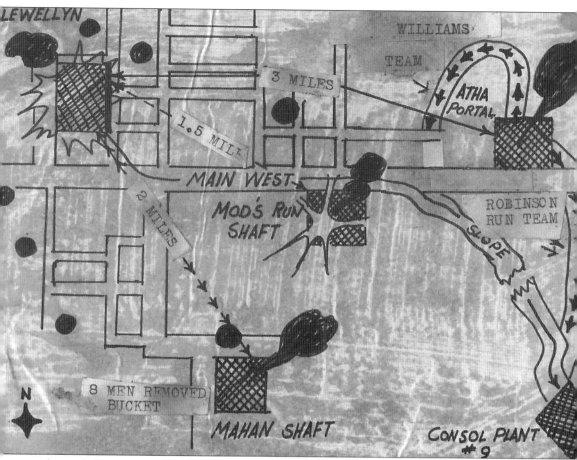

ARTIST'S DRAWING OF PORTAL LOCATIONS. The *Fairmont Times* ran an artist's drawing showing the locations of the various mine portals, the distance aboveground to each, and areas where rescue teams attempted to enter the mine's underground passageways. The typed label next to the Mahan Run portal indicates where the eight men were brought to safety using a construction crane and bucket. The map used is very simple so any layperson can better understand the layout of the mine and the locations of the mine shafts and main slope. A mine is like a small city underground, with passageways replacing streets and mounds of rock and coal replacing city blocks. Without the aid of computer animation at that time, this was a very simple approach to a complicated situation.

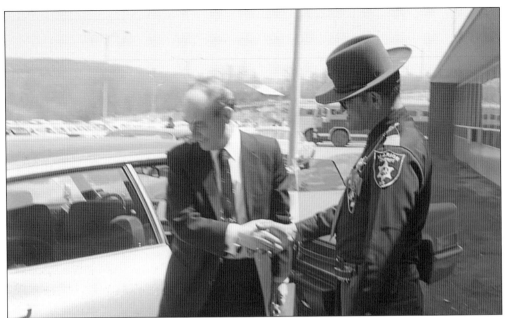

UMWA PRESIDENT TONY BOYLE. Upon his arrival at the Champion store, Ace Smith, a member of the Marion County Sheriff's Department, greets Tony Boyle. Boyle was president of the United Mine Workers of America (UMWA) at the time of this tragedy. Boyle held this position until the early 1970s, when he was found guilty of embezzling from the union. He was found guilty of the murder of Joseph Albert "Jock" Yablonski at a second trial held February 1978.

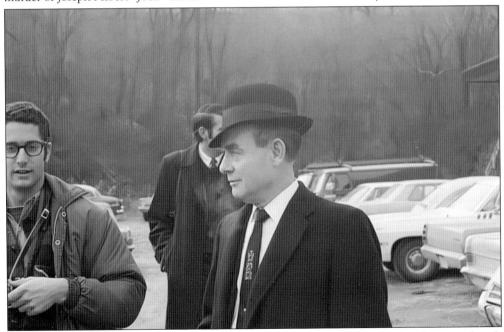

UMWA PRESIDENT ARRIVES. Tony Boyle, UMWA president, was immediately greeted with questions from members of the news media regarding the union's position concerning the rescue of the 78 trapped miners. As head of the union, Boyle spoke for all union coal miners across the nation and their fight for better working conditions.

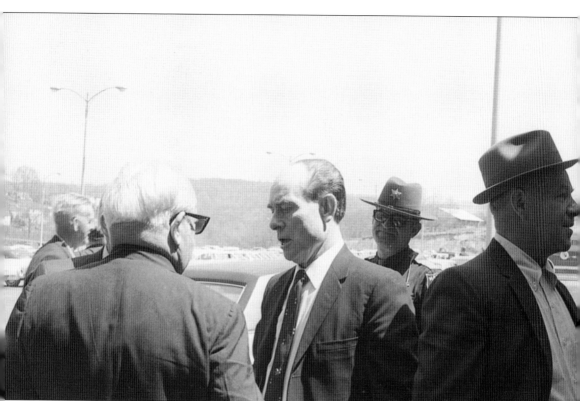

EVANS INTERVIEWS BOYLE. Bill Evans (foreground) and Tony Boyle (center) had met on several occasions prior to the encounter at the Farmington Mine. Evans's support of the UMWA's efforts to help better the safety for miners was always a topic of concern, and he had worked with Boyle on many occasions. Because of the trust established early on in this relationship, Evans was able to approach Boyle without a microphone between them.

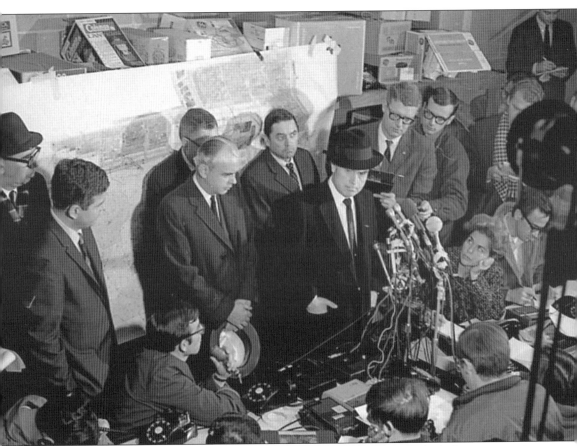

BOYLE ADDRESS. Tony Boyle addresses the news media and families at the makeshift news center in the Champion store. Also pictured are James McCartney (directly behind Boyle); John Corcoran, president of Consolidation Coal Company (to the left of Boyle); and Rex Lauck, assistant editor of *United Mine Workers Journal* (at far left, in the hat).

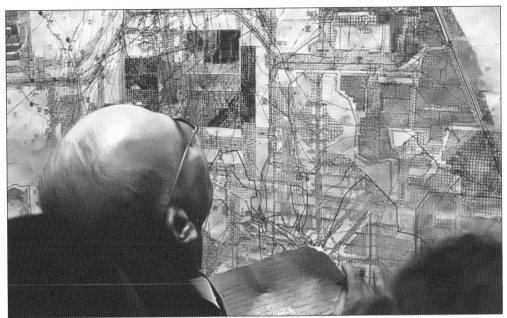

MAP OF THE MINE. Large maps were brought into the back room of the Champion store and hung hurriedly to help news personnel better understand what was taking place underground. Many times the news briefings were like class lectures, with explanations to the media about the workings inside of a coal mine. It was hard for some reporters to grasp just how large of an area the mine covered underground.

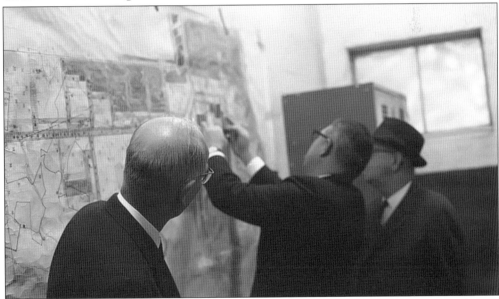

SPECULATING ON MANY POSSIBILITIES. William N. Poundstone, executive vice president of Consolidation Coal Company, is looking at a map of the mine in an attempt to speculate where some of the trapped miners could have gone for shelter after the explosion. Many hours were spent by him and other mine officials looking at these maps to determine a plan for getting to the trapped miners. There are miles of tunnels and areas where someone could have gone to safety had he survived the initial blast.

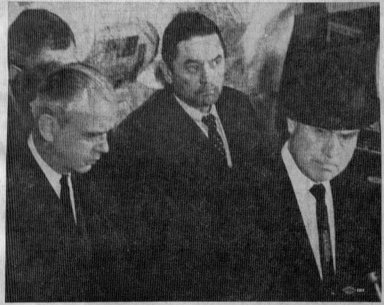

United Mine Workers Journal, December 1, 1968. The *United Mine Workers Journal* was published twice monthly, and this issue has several pages dedicated to the incident. On the cover, Tony Boyle is seen expressing his concern for the 78 miners trapped underground. Inside, the lead article by Rex Lauck, assistant editor of the *United Mine Workers Journal*, states, "A violent explosion—perhaps the most violent in the history of coal mining anywhere—roared through Mountaineer Coal Co's Farmington No. 9 Mine located at this hilltop near Farmington W. Va., on November 20."

HUMAN SIDE OF NEWS MEDIA. The news media spent hours of downtime waiting for the next briefing from mine officials concerning the progress of the rescue operations. This newsman took his bologna sandwich and shared it with one of the abandoned cats wandering around the Champion store.

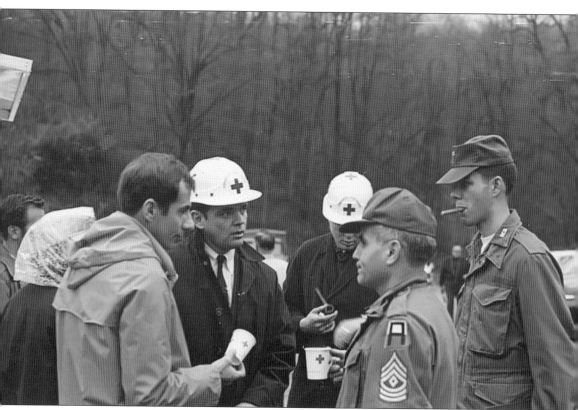

NATIONAL GUARD CALLED OUT TO ASSIST. The 201st Field Artillery Battalion of the West Virginia National Guard in Fairmont was called out to assist Sgt. Anthony Pulice Jr. (in the foreground) and Commander Ronnie Williams (with the cigar) in coordinating with police personnel in helping to man roadblocks on the roads leading to the various mine portals. The National Guard unit consisted of 120 men who were being rotated around the clock for the duration of the attempted rescue of the 78 miners.

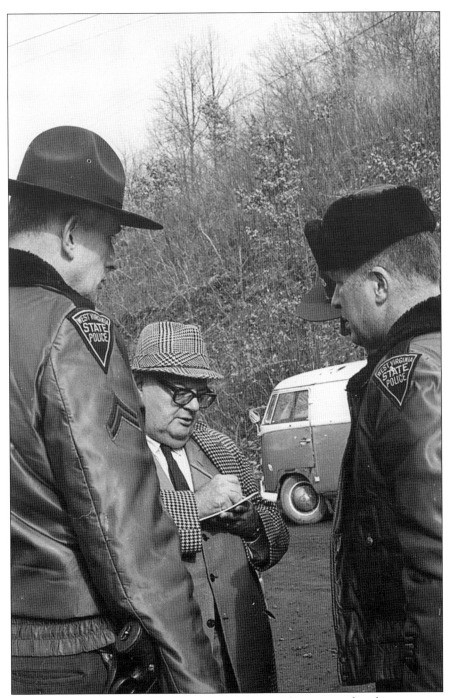

WEST VIRGINIA STATE TROOPER. The West Virginia State Police were on hand to support security efforts and to help keep roadways open for all rescue operations. Bill Evans is gathering information from two of the troopers, Don Lake (left) and Russ Miller (right). These two men were a part of one of several detachments from across the state to lend support. Along with the state police, the West Virginia National Guard, the Marion County Deputy Sherriff's Department, and the Marion County Police Reserve were all present to assist with security operations.

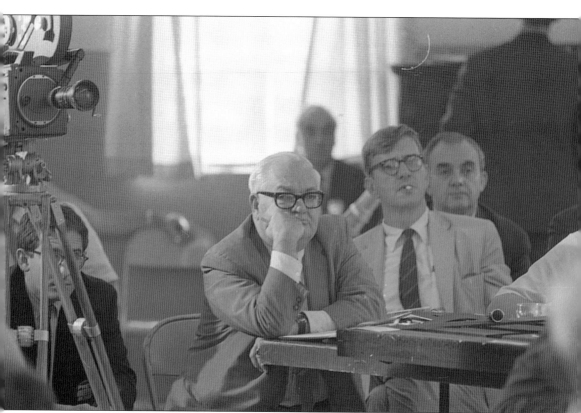

William Dent "Bill" Evans. Bill Evans was the editor of the *Fairmont Times* and covered several mining accidents over the course of his tenure as reporter and editor. He was one of West Virginia's authorities on sports, politics, and the mining industry. His writing style is factual and to the point, and his editorials reflect his strong dedication to fighting for what was right and just. Respected by many across the state and nation, he was a strong Democrat supporting state and national issues. During John F. Kennedy's run for president, Evans was very influential in the state, showing Kennedy strong support in the *Fairmont Times*. Sport personalities like Jerry West, Hot Rod Hundley, and Sam Huff were among those who personally knew and respected Evans for his no-holds-barred reporting. Good, bad, or indifferent, he told it as he saw it and was appreciated for his scrupulousness. Evans supported local sport teams from high school and college. He never missed going to and reporting on sporting events at West Virginia University.

BILL EVANS. Evans only had one good eye and his typing style was very unorthodox; using only two fingers, he would pound out news articles with great passion. Taken the first day of the Farmington Mine disaster, this photograph shows his handwritten notes to be very cryptic or unreadable to most, but he was able to decipher them and produce a very factual and accurate account of what took place at the scene of the event.

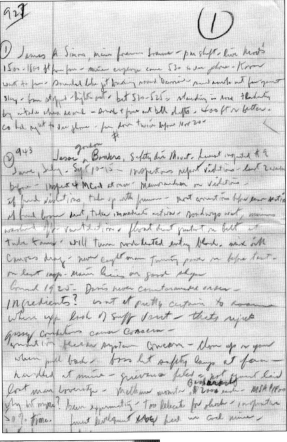

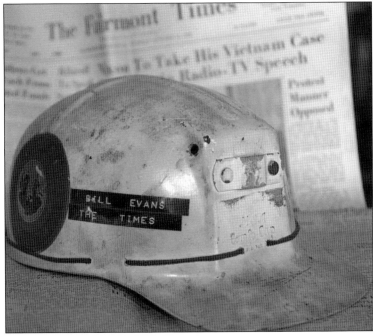

BILL EVANS'S MINER'S CAP. This miner's cap, with the State Department of Mines sticker and Bill Evans's name attached to the side, was given to him by top officials of that department because of his on scene reporting and the accuracy of his note taking. Bill Evans would oftentimes appear at mine accident hearings as an eyewitness because of his notes taken at the scene.

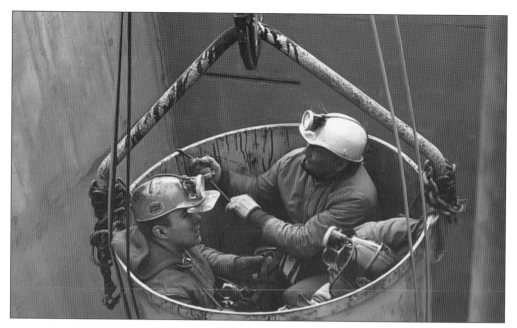

BUCKET SHOT ONE, NEVER PREVIOUSLY PUBLISHED. These two photographs, never before published, show the last three men to come out of the Farmington No. 9 coal mine after the cateye shift on November 20, 1968. The makeshift rescue apparatus, a construction crane and bucket being used at another location that morning, came to liberate eight miners. These photographs show how the men in the bucket are working to untangle the hoist cable lifting them from the shaft. They were just 15 feet from the top of the mine shaft and safety and approximately 560 feet above the mine floor below them when the cable jammed.

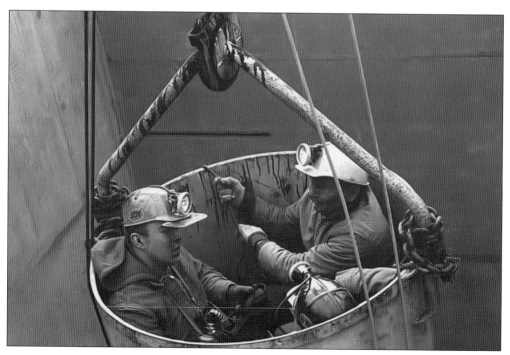

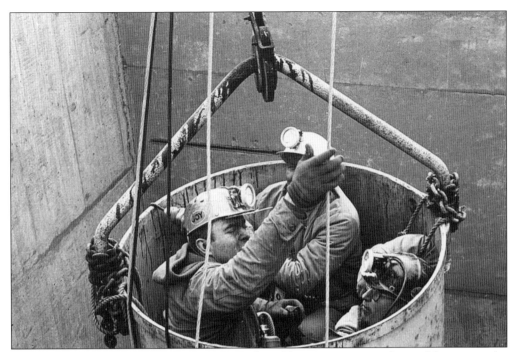

TENSE MOMENT. Unsuccessful attempts to get the cable moving prompted one of the men in the bucket to suggest the crane operator raise the boom of the crane. The operator slowly raised the boom, and the bucket cleared the top of the shaft. The operator swung the boom away from the shaft and lowered it and the bucket to the ground. Medical personnel were there to help the last three miners out of the bucket and back to safety.

BUCKET SHOT. These are the last three men to come out from the depths of the Farmington Mine on the morning of November 20, 1968. They were rescued using a construction crane and a bucket from a nearby project. Gary Martin (left), Bud Hillberry (right), and Charlie Crim (back to camera) were among the 99 men working the midnight cateye shift.

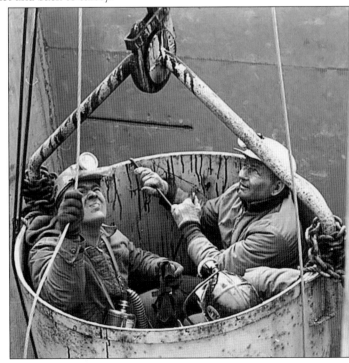

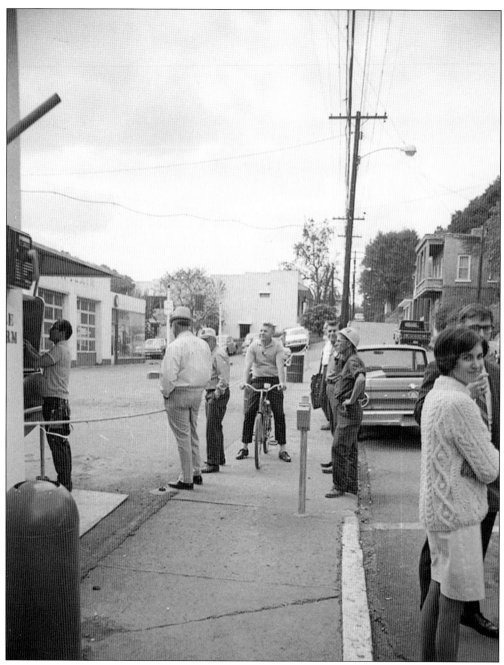

PHONE LINES INSTALLED. As the media grew, so did the demand to communicate with the outside world. The telephone was the quickest way for news reporters to correspond with their home offices. The phone company was called in, and several temporary phone lines were strung through Farmington to facilitate this hunger to get the news out of this remote area.

Three

Rescue and Recovery

Recovery operation would start in September 1969 with removal of the seal at Atha's Run. Once the seal came off, a fan was started remotely, keeping workers out of harm's way just in case a spark set off any methane gas still in the mine. Shortly after that, the number one fan at the main slope was started. When methane readings were within a safe limit, men were lowered down Atha's elevator shaft.

This was the beginning of a recovery operation that would take several months to complete. The fire and explosion had caused massive damage in the mine. Steel railroad track in the main haulage tunnels was twisted and had to be removed before anyone could move deeper into the mine. The roof had fallen in many places. Coal had to be mined and taken out. Safety was the first concern of the recovery team, which worked cautiously to ensure no other lives would be lost during the recovery process.

The first body was found early one morning in October 1969. The state police and the Marion County coroner, Dr. Charles H. Koon, made positive identification of the body based on the number found on his cap lamp and his artificial leg. The coroner did not perform any autopsies on any of the bodies at the time, stating cause of death was the explosion. Had autopsies been performed, it might have given insight as to how close to the main blast the bodies had been. Burnt tissue in the lungs would have indicated the bodies were closer to the main blast, and no burnt tissue would indicate death by asphyxiation and the bodies being farther away from the epicenter of the blast. This could have helped determine the main point of ignition.

One of the troopers working that detail at the time was Trooper Ron Crites from the Sutton Detachment of the West Virginia State Police. Crites retired in the early 1990s and currently resides in Preston County. After his retirement from the state police, he entered politics, got elected as a county commissioner, and was later elected as sheriff of Preston County. Crites recalled the identification of one of the bodies when personnel were reasonably sure they had identified the right person but wanted to be 100 percent sure. A small key was found on the body, and it did not appear to fit any locks on mine property. The trooper, along with Consol officials, traveled to the home of the assumed man. Knocking at the door and identifying themselves, they explained to the widow they wanted to be sure they had made proper identification of her husband's body. Trooper Crites presented her with the key and asked if she had any idea what the key might fit. She told the officials yes, it fit her husband's gun cabinet, and sure enough, it did unlock the cabinet.

Recovery operations continued for almost 10 years, with much controversy as to how it was being handled by the company. Several of the miners' widows refused to sign agreements for settlement with the company and did not want to give up on finding every man that was in the mine when the explosion took place. On April 19, 1978, Consol announced the closure plan of

the mine, stating safety concerns for recovery workers as one of the main reasons for stopping the operation. The mine was permanently sealed shortly after that, with 19 of the bodies entombed forever in Consol's Farmington No. 9 mine.

Here are the names of the 19 bodies still buried in the mine: Jack O. Armstrong, Orval D. Beam, John Joseph Bingamon, Louis S. Boros, William E. Currence, Howard A. Deel, Virgil A. "Pete" Forte, Hilery Wade Foster, Aulda G. Freeman Jr., Paul F. Henderson, Junior M. Jenkins, Pete J. Kaznoski Sr., Frank Matish, Emilio D. Megna, Jack D. Michael, John Sopuch, William L. Takacs, Edwin A. Tennant, and Edward A. Williams.

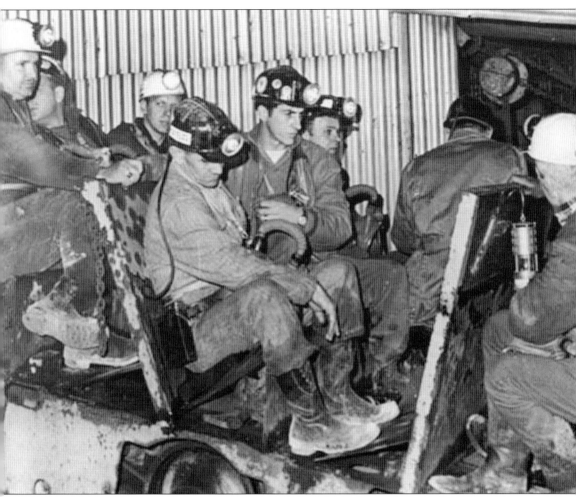

ENTRY TEAM. One of the entry teams is getting ready to descend into the Farmington No. 9 mine after several explosions occurred deep underground. These men had no real idea as to what they would encounter but were dedicated to helping locate any men that may have survived the blast. Their efforts did not get them into the mine as deeply as they had hoped because of the conditions found there, and they did not find any survivors in the little exploration they did complete.

RESCUE TEAM WAITS FOR NEXT MOVE. One could only imagination what thoughts were going though these miners' minds knowing that any one of them could have been one of the 78 trapped underground. Coal mining is in the blood of these men, and not only was it a way to make a living, but it was an occupation that became a big part of one's life. The job was more like a brotherhood, where everyone watches out for each other.

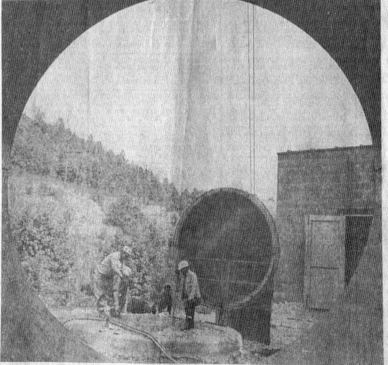

UNITED MINE WORKERS JOURNAL, SEPTEMBER 15, 1969. The front page shows a photograph of the seal at the Atha's Run portal being removed to prepare for the recovery of the 78 miners who had been entombed by the explosion and fire on November 20, 1968. The main headline on page three states, "Consol No. 9 Is Reopened," and in a box below that is this comment: "Coal Miners Have Earned the Right to Safe and Dust-Free Mines."

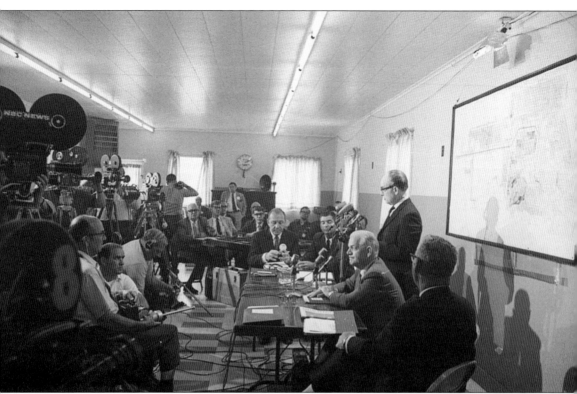

BOYLE ANNOUNCES MINE REOPENING. Farmington Town Hall was again busy with mining officials and news media on September 10, 1969. Tony Boyle made the announcement about the reopening of the Farmington Mine after it had been sealed for almost 10 months. The miners' widows and other dependents received the plans for recovery in gripped silence at a 7:30 p.m. meeting at the town hall. At the table are Peter Ferretti, vice president of Consolidation Coal Company (left, facing camera); John Ashcraft, West Virginia Department of Mines (right, facing camera); Tony Boyle, UMWA president (standing); Lewes E. Evans, UMWA safety director (profile); James Westfield, assistant director, Coal Mine Safety, US Bureau of Mines (back to camera).

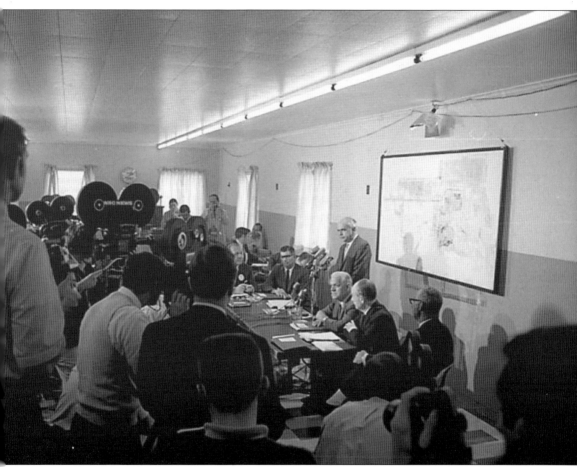

NEW CONFERENCE, SEPTEMBER 11, 1969. Pictured on September 11, 1969, is a press briefing held at the Farmington Town Hall about the reopening of Farmington No. 9 mine. At the table are, from left to right, Peter Ferretti, vice president of Consolidation Coal Company; John Ashcraft, director of West Virginia Department of Mines; John Corcoran, president of Consolidation Coal Company; Lewes E. Evans, UMWA safety director; Tony Boyle, UMWA president; and James Westfield, assistant director, Coal Mine Safety, US Bureau of Mines.

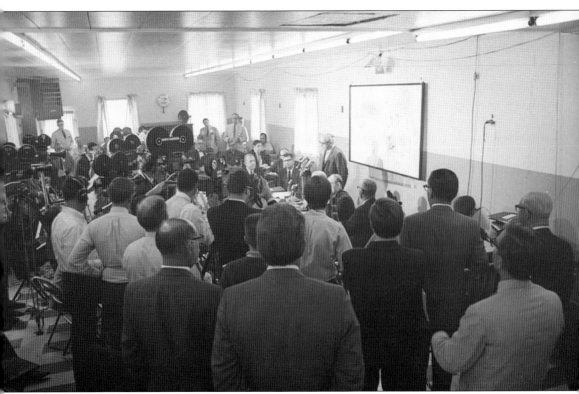

Town Hall Filled Once Again. Farmington Town Hall was once again filled with news teams from around the country to hear plans regarding the mine reopening and recovery operation. The film cameras were once again rolling in the small community of Farmington. It had been 10 months, and everyone was wondering how and when Consol would divulge a strategy to recover the bodies of the 78 entombed miners. John Corcoran made the announcement and laid out the plan. The United Mine Workers of America Union, along with the West Virginia Department of Mines and the Federal Department of Mines, had to agree with the company plan before it could be executed.

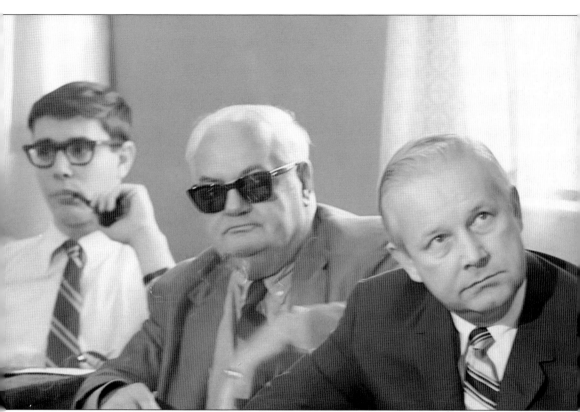

GOVERNOR. Governor-elect Hulett C. Smith (right) and Bill Evans (center) listen to company officials as they update the media on the progress being made to recover the bodies of trapped miners. Evans was the editor of the *Fairmont Times* in Fairmont, West Virginia, and reported the news events from Farmington starting early on that first day in 1968.

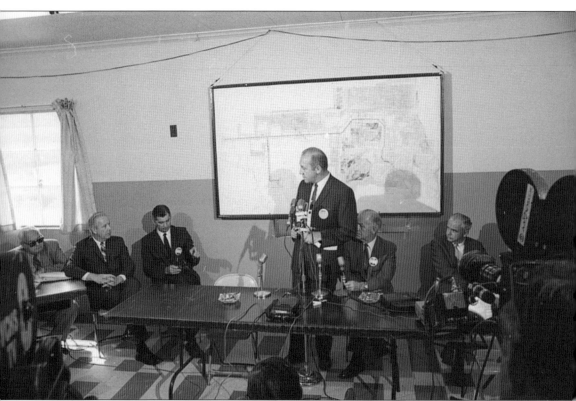

VICE PRESIDENT FERRETTI ADDRESSES THE GOVERNOR. Consol vice president Peter Ferretti addresses a question from Gov. Hulett Smith concerning the next entry by rescue teams into the mine. Much consideration had to be given before sending in rescue teams because there had been several smaller explosions after the initial blast in November. Neither the company nor any of the other agencies wanted to have more lives lost in an attempt to recover the miners. Many of these officials never left Farmington during this 11-day ordeal.

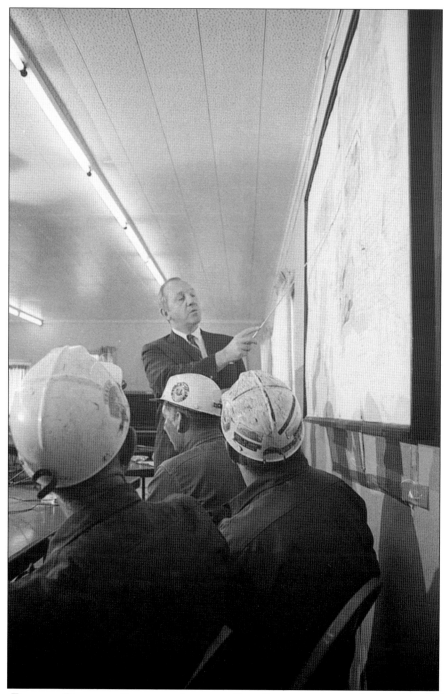

PETER FERRETTI DISCUSSES RECOVERY ATTEMPT. Peter Ferretti, vice president of Consolidation Coal Company, talks about an attempt the rescue teams made into the mine. The situation had progressed to the point that the news media had been moved to a building located in the heart of Farmington, above one of the stores. There was now more space for reporters and cameras to set up. The families were being cared for at the James Fork United Methodist Church. This was a huge improvement for all parties involved.

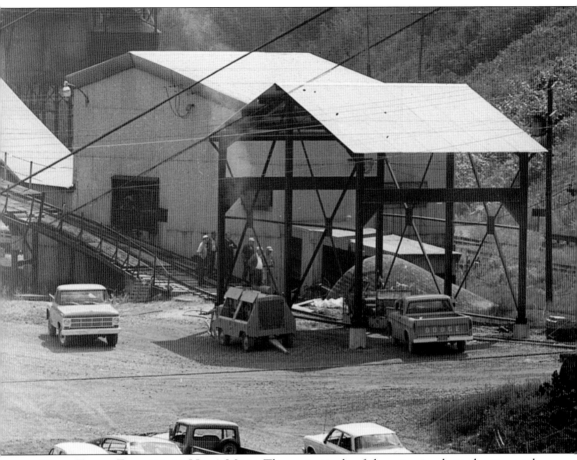

MAIN TIPPLE, FARMINGTON NO. 9 MINE. The main tipple of the mine is where the raw coal coming out of the ground is received and processed. Small railcars transport the coal from deep underground to the surface and into the main tipple where it would be washed, cleaned, dried, and separated into various sizes for different applications according to the customer's request. Before the days of automation in the mining industry, the coal was brought out of the ground using mules or horses. These animals were usually housed in the mines and seldom saw the light of day. They were well cared for because getting the coal to the surface was most important. At that time, the animals would pull small wooden carts with steel wheels traveling on steel tracks. This process was later modernized using small electric driven locomotives to pull much larger steel cars out of the mine. Today, there is no visible sign of the once large industrial complex used to process approximately 10,000 tons of coal on a daily basis. All of the structures have been demolished and the land taken over by Mother Nature. The penetrations into the ground have all been sealed along with the remaining 19 bodies of the miners never recovered from the disaster.

BACKSIDE OF SLOPE. This view looking from the backside of the slope where recovery operations were being conducted shows the tracks leading out of the mine and going into the preparation plant. Normally, cars loaded with tons of coal would travel this route, taking the coal to be cleaned and processed for shipment to local and distant electrical generation plants. This day, however, state and federal mining officials are on standby waiting for rescue teams to come out of the mine and report their findings.

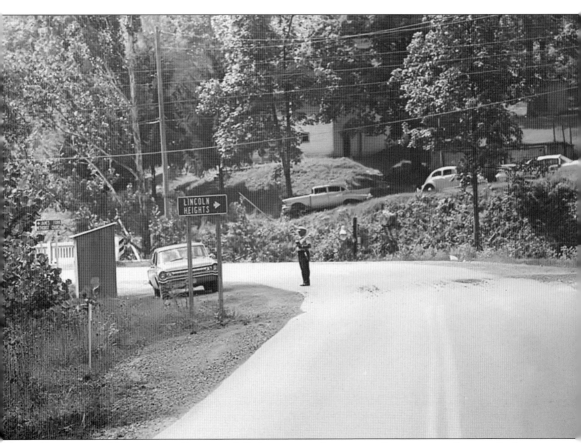

ROADBLOCKS ESTABLISHED. Because of all the news media personnel, curiosity seekers, and others interested to see and be a part of what was taking place in and around the mine, roadblocks were established throughout the area so rescue vehicles, rescue workers, and mining officials had clear access to all the mine portals and buildings. One photographer, who went around a roadblock, was taken by police to the press room before being released.

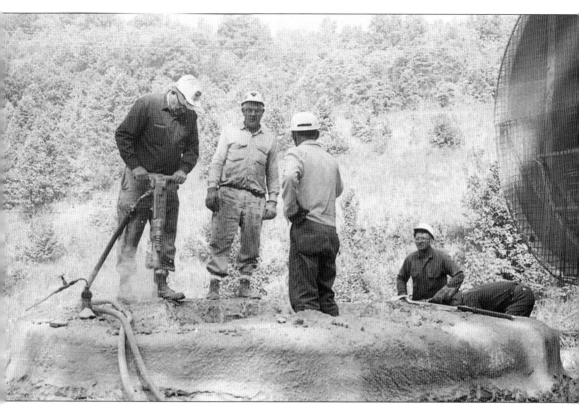

REENTRY WORK BEGINS AT ATHA'S RUN PORTAL. On September 12, 1969, work began to remove the seal at the Atha's Run portal, taking the first step to recover the bodies of the 78 miners entombed when the mine was sealed in November 1968. Workmen used jackhammers with beryllium tips to prevent any sparks from igniting any methane gas that might escape. First, the concrete seal was removed, and then a large steel cap was taken off. A remote-controlled fan was used to speed dispersal of methane gas expected to escape once any cracks were opened.

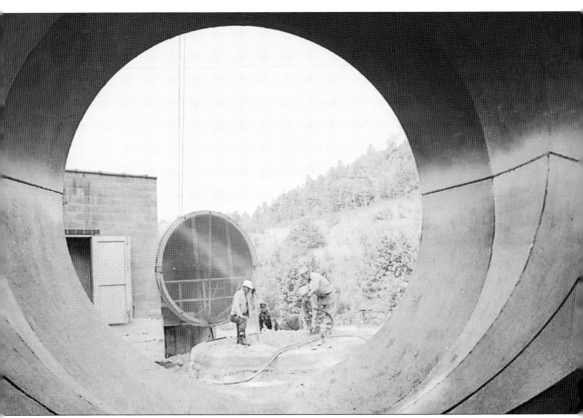

ATHA'S RUN PORTAL REOPENED. Men worked with jackhammers to remove the concrete cover used to seal the mine for the past 10 months. The sealing of the mine took place on November 30, 1968—ten days after the initial blast and after all hope had been given up to save any of the miners underground. Efforts to reduce the methane gas in the mine were impossible with the small auxiliary fans being used. The decision to close the mine was collectively made by Consol Company officials, federal mine inspectors, and the United Mine Workers of America.

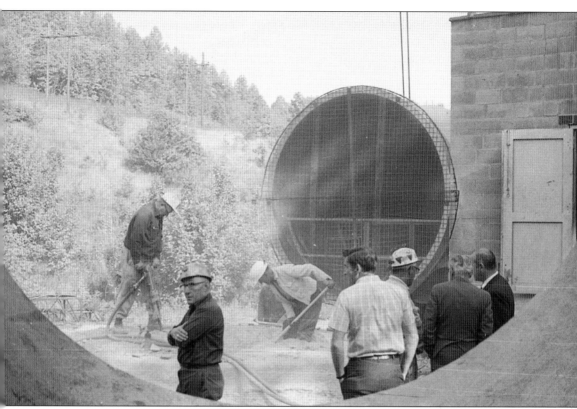

JOHN CORCORAN AND PETER FERRETTI. John Corcoran (fifth from left), president of Consol Coal Company, and Peter Ferretti (right), vice president of Consol Coal Company, are at the Atha's Run portal to inspect firsthand the removal of the concrete and steel seal covering the air shaft. The removal of this seal required all safety measures be taken to ensure the well-being of the construction crews performing this task. Methane gas had been trapped in the sealed mine for 10 months, and any careless act could cause catastrophic results.

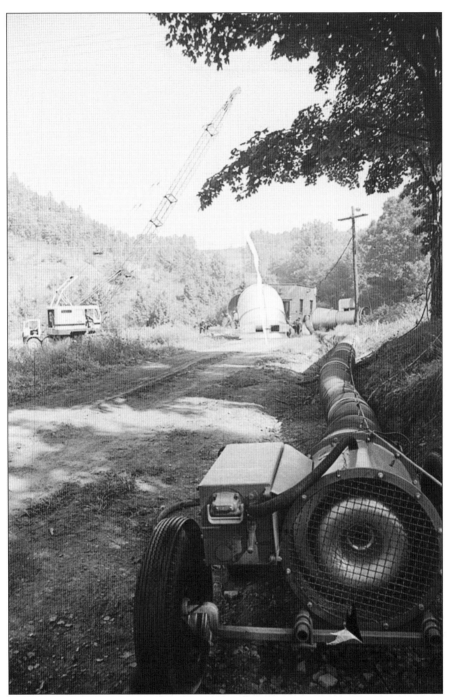

ELBOW BEING INSTALLED. Once the seal was removed, a large elbow was lifted back into place to make the connection between the mine shaft and the No. 2 fan house. The area was cleared of all personnel, and the fan was started remotely in the event of any ignition of escaping methane gas. The next step was to open two large vent pipes in the Atha's Run elevator shaft, which would assist in getting fresh air into the area. With fresh air in the elevator shaft, the recovery crews could now remove the seal, allowing recovery operations to proceed.

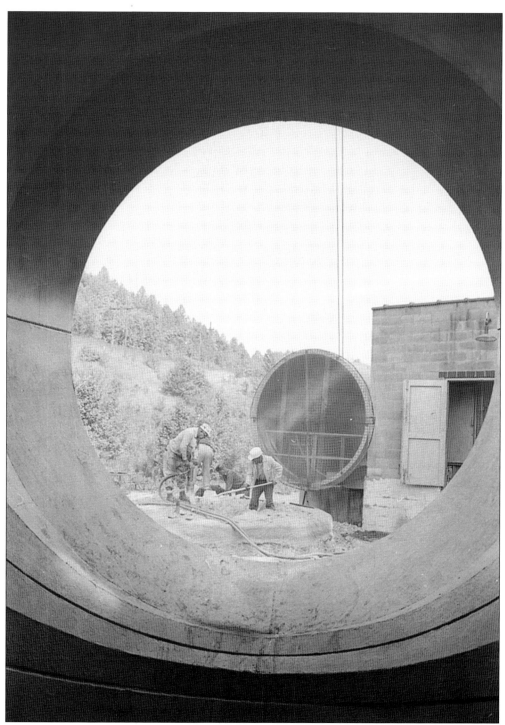

VIEW FROM INSIDE ELBOW. News media was restricted from being in the area around Atha's Run portal during the seal removal process that morning. However, one photographer managed to find a back way in before the crew and officials arrived that morning and, taking shelter in the large elbow, managed to get this image. The photographer was not noticed by anyone.

BOREHOLE SAMPLES. Samples of air were taken during the time the mine was sealed. This was accomplished by pulling air samples through boreholes drilled from the surface to various locations underground in the mine, and several sections of steel pipe would be lowered down the holes. After the pipes reached the mine's interior, air samples could be taken. This allowed the mining officials to test the amount of methane gas in the various areas of the mine so they could determine if fresh air was reaching that section. Once air samples were at a safe level, rescue teams were permitted to move in that direction.

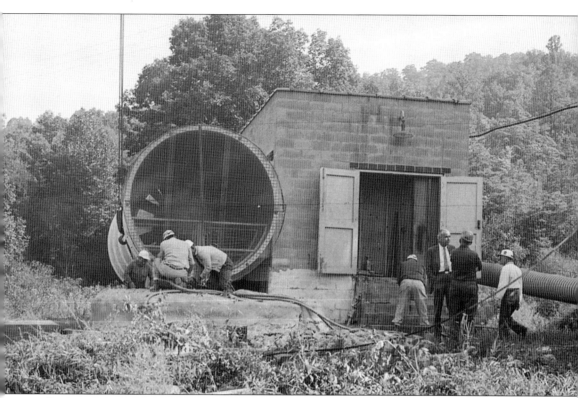

PREPARING ATHA'S RUN FAN. John Corcoran (third from right), president of Consol Coal Company, discusses the integrity of the Atha's Run fan motor and controls being checked by members of the maintenance crews. The fan had been damaged by the explosion, but after repairs, it was now ready to go back into service. This was a very critical step in getting fresh air back into a mine with high levels of methane gas that had been sealed for 10 months.

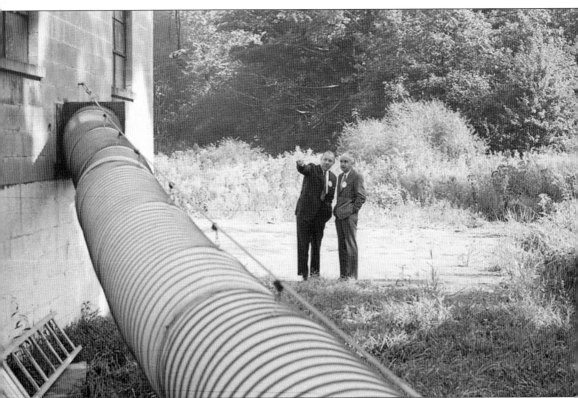

PETER FERRETTI, VICE PRESIDENT OF CONSOL COAL COMPANY, AND JOHN CORCORAN, PRESIDENT OF CONSOL COAL COMPANY. Peter Ferretti (left), vice president of Consol Coal Company, explains to John Corcoran (right), president of Consol Coal Company, the use of a portable fan during the seal removal procedure. The fan is being used to force fresh air into the mine shaft to help reduce the amount of methane gas while work proceeded with seal removal. Every step of precaution was taken to protect the workers during this critical process.

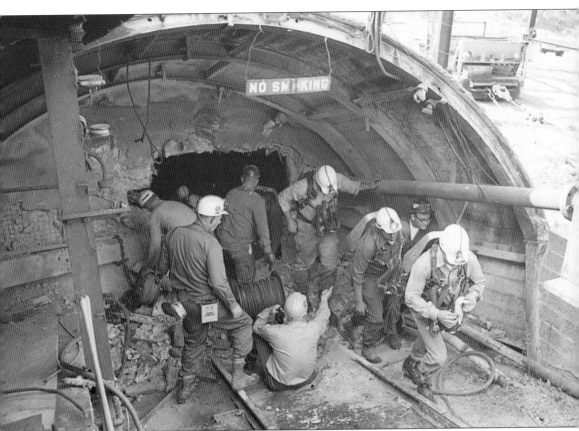

FIRST TEAM OUT OF THE MINE. The first task the rescue team would perform would be to walk down the main slope, which was a 16-degree incline about 1,600 feet in length, from the surface to the underground working area of the mine. The team entered the slope, walked to the bottom, and opened large doors to allow the flow of fresh air to once again circulate through the mine entryway. Many members of the rescue team working at the mine were volunteers and would continue working during the entire recovery operation. Here, members of the team exit the mine and turn in their check tags.

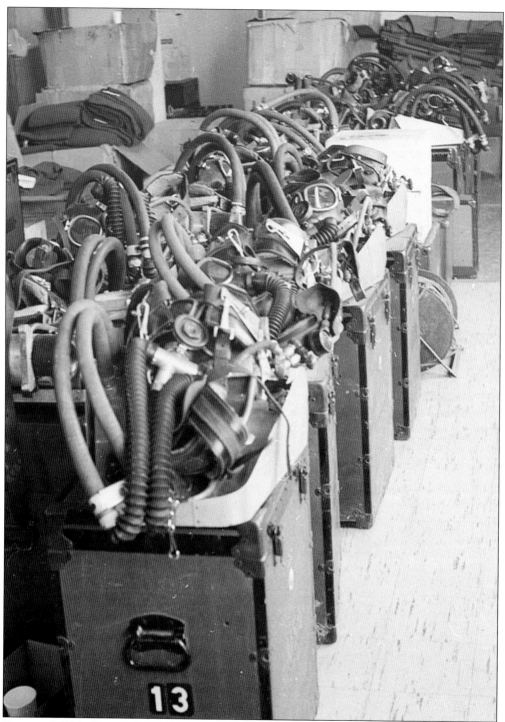

DRAGER SCBA. Drager SCBA (Self-Contained Breathing Apparatus) was used by the rescue teams entering the mine. The rescue team wore these to protect themselves from the fumes and harsh environment of the mine. Unfortunately, they could only stay in the mine for short periods of time due to the limited air supply they carried on their backs.

RESCUE TEAMS ON STANDBY. The rescue teams established a headquarters at the UMWA 4047 hall on Atha's Run midway between the No. 9 slope and Atha's Run portal. They were there around the clock so they could respond to any request or make an entry into the mine to assist with any underground exploration or recovery.

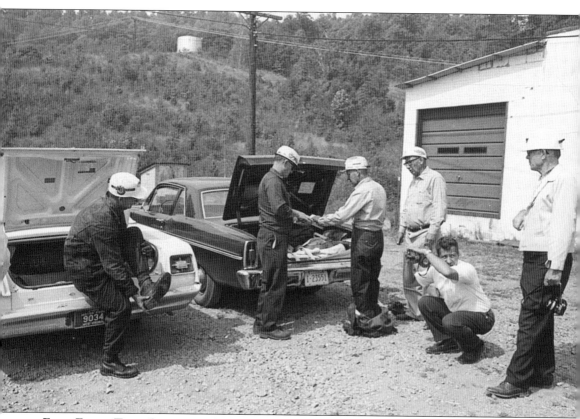

FIRST ENTRY TEAM OUT OF THE MINE. Normally, the walls in a mine are covered with a lime powder called rock dust. When the teams came out of the mine for the first time, they stated that the walls were as black as hell. All of the rock dust was now soot-covered or the lime had dissolved by all the moisture in the sealed mine. Seeing in those conditions was difficult at best, slowing down any progress.

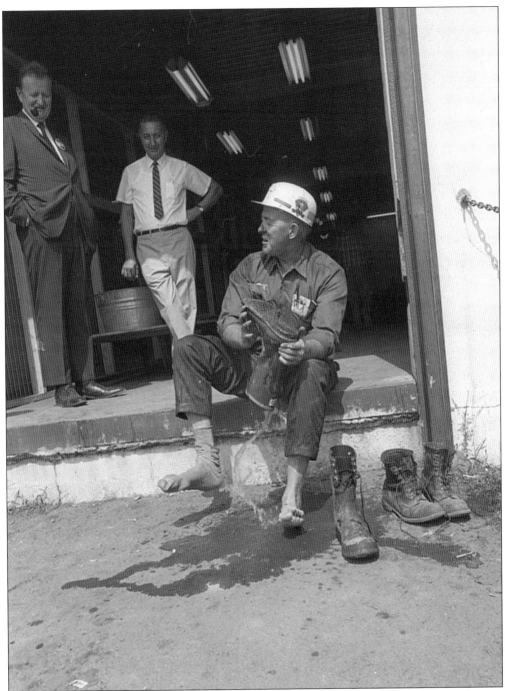

WATER INSIDE THE MINE. One miner is seen emptying the water from his boot. He is explaining what was encountered in just a very short exploration inside the mine that had been sealed for some 10 months. Water filled the mine because no pumps were running while it was sealed. These first recovery teams did not find any bodies. It was not until late October that year when the first body was found and recovered. It was discovered floating in about three feet of water approximately a mile from the Plum Run overcast.

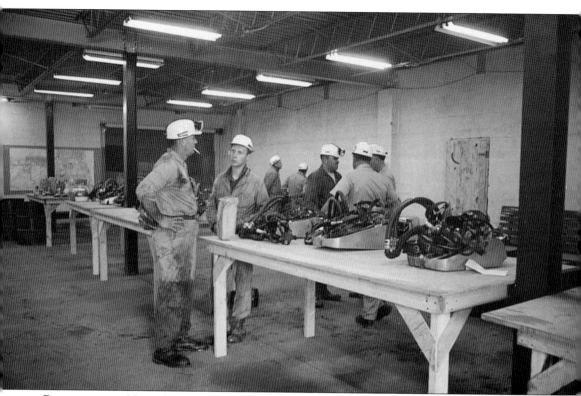

PREPARING FOR NEWS CONFERENCE. The first entry team to come out of the mine after it was reopened discusses the conditions the men found on their first exploration. One miner said it was dark as hell because all of the rock dust was gone from the walls and roof. Soot from the fire coated the surfaces and made seeing extremely difficult in the total blackness.

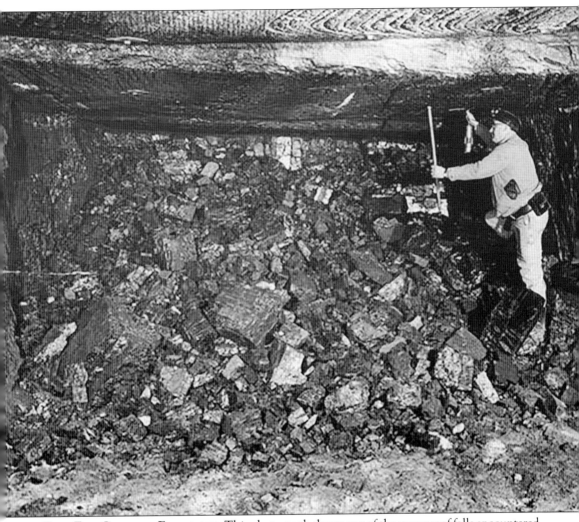

ROOF FALL CAUSED BY EXPLOSIONS. This photograph shows one of the many roof falls encountered during the recovery operation at Farmington No. 9 mine. It was not just one explosion that took place at the mine, but several subsequent ones also occurred days after that initial one. Many of the blasts shook the earth and could be felt miles away from the mine. The blasts also caused tons of coal and rock to come crashing down into the mine passageway. (Courtesy of John Brock.)

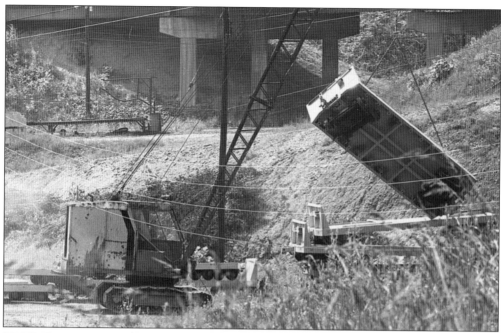

PREPARATION FOR RECOVERY OPERATIONS. This crane is lifting railcars normally used to transport equipment and material into and out of the mine during mining operations. Preparations were carried out to get these units ready in the event they would be needed to move materials into or out of the mine during the recovery process. It was most disappointing these cars were not put into use for any recovery of the 78 miners at that time.

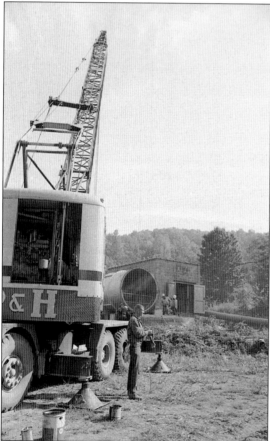

CRANE USED FOR RESCUE. The rescue of the eight miners at the Mahan Run portal was carried out using a construction crane. This crane could be driven on roads, so it was transported from a nearby construction site to the Mahan Run portal that November morning in 1968. The construction workers helped in the recovery of the miners that morning.

STATE INSPECTORS DISCUSS SITUATION. John Ashcraft (center), director of the West Virginia Department of Mines, discusses the current circumstances surrounding rescue operation of the miners with Leslie Ryan (right), the state's top mine inspector. Ryan had been at the mine on many occasions and knew the dangers associated with this particular mining operation. He knew the mine was very gaseous and that it was necessary to proceed with great caution during any recovery operation. The man at left is unidentified.

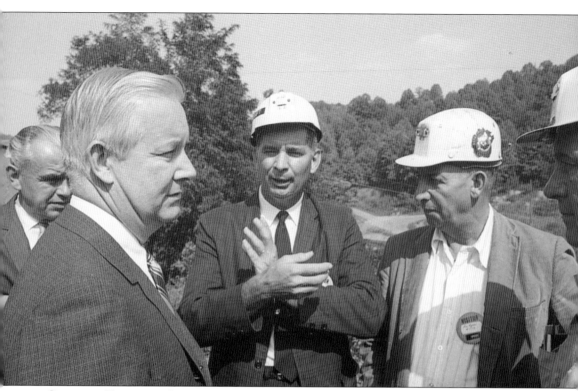

GOVERNOR TALKS WITH STATE DEPARTMENT OFFICIALS. Gov. Hulett Smith (second from left) talks over the situation with John Ashcraft (third from left), director of the West Virginia Department of Mines; Leslie Ryan (right), inspector-at-large for the department; and John Corcoran (left), president of Consol Coal Company. Ashcraft had major concerns about entering the mine and felt that any hurried attempt could cost the loss of more miners. Ashcraft made a statement at one of the press conferences: "I'm just as anxious to get those men because many of them were my friends. It is better to wait a little longer."

Four

LIFE CONTINUES

Farmington is a small town in Marion County, West Virginia, in the northern end of the state, not too far from the Pennsylvania border. The small town has not changed much over the past 45 years in general appearance, but there are no longer any coal mines operating in the community. The Farmington No. 9 coal mine is a memory to some of the older residents, but to the younger residents of the community, it is just a story. There is little physical evidence today to show the mine even existed. After the mine was closed in 1978, all the structures were dismantled, and in most cases, there is no evidence they even existed.

The small Champion store that was the center of attention for several days in November 1968 is still mostly intact. The building has been converted into a garage for personal use, and without past knowledge of the mine incident, no one would ever know it was once a part of history. Across the street, nothing remains of the main tipple and processing plant, and the little church that stood in the shadow of the preparation plant is now a residence.

One thing did change because of this little community and that has impacted mine safety since 1969: the Federal Coal Mine Health and Safety Act, US Public Law 91-173, generally referred to as the Coal Act, was passed in the 91st US congressional session and signed into law by the 37th president of the United States, Richard Nixon, on December 30, 1969.

The Coal Act set new standards for the coal mining industry and requires two annual inspections of every surface coal mine and four at every underground mine. The Coal Act also set new monetary penalties for violations, and criminal penalties were also established for known violations.

Higher standards were also established for the miners' health by including specific procedures for mandatory health and safety standards. Many miners suffered from lung disease caused by all the coal dust in the mines. Black lung, or pneumoconiosis, was a killer of many coal miners. Stricter regulations were established to minimize coal dust in the mine to improve health and safety of the miners and reduce the risk of explosion.

Another mine explosion at the Upper Big Branch at Montcoal, West Virginia, about 30 miles south of Charleston, the state capital, occurred on April 5, 2010, with 29 miners losing their lives. Massey Energy owned this mine, and after investigation, it was found in 2015 that the company did not follow the safety standards established and willfully violated these standards. The results of these violations caused the company to pay $209 million in settlement of the fines. Two Massey Energy officials face prison time, including Don Blankenship, former CEO of the company, due to knowingly covering up safety violations. The chapter of coal mining in West Virginia has all but come to a close due to federal regulations because of the Clean Air Act and the Obama-Biden comprehensive New Energy for America plan. The plan calls for more renewable fuels to be used for the generation of electricity, reducing the use of fossil fuels (including coal) and eliminating

the need for coal mining. At one time, coal was used to generate the majority of electricity in the United States. That is no longer the case.

No one knows what the future may hold for the coal industry, but it is certain that Farmington, West Virginia, will not be the site of any further coal production. It will be the place where the course of the industry was changed and the 78 miners who lost their lives in November 1968 will be remembered as silent heroes.

MAP OF STATE. This map shows the state of West Virginia, and the dot marks the location of Farmington, in Marion County.

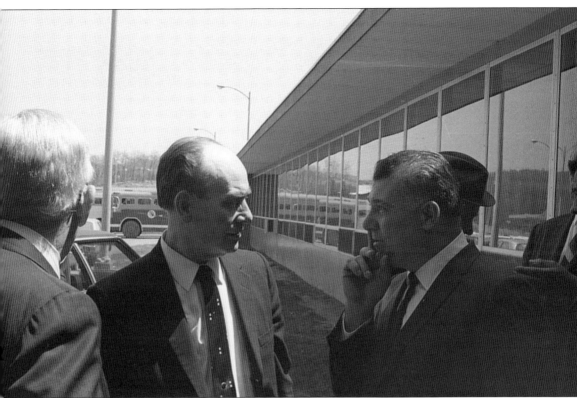

BOYLE AT MARION COUNTY ARMORY. Tony Boyle (center), president of UMWA, is seen talking with retired members of the union along with union officials. The union was rallying heavily for the upcoming US legislative session to support the passage of a new mine safety bill. The Farmington No. 9 explosion was a huge factor in getting the union support to address Congress for more safety legislation for the mining industry.

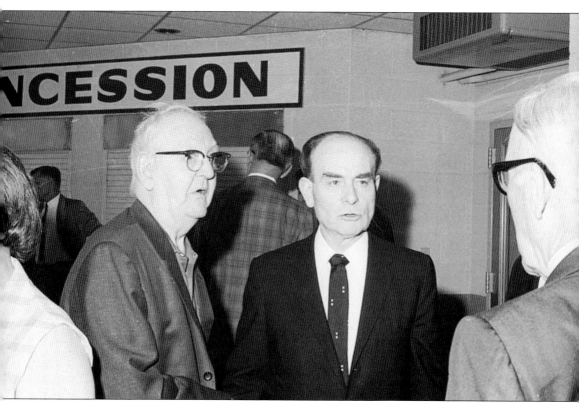

BOYLE TALKS WITH RETIREES. The rally held at the Marion County Armory in Fairmont was well attended by many rank-and-file UMWA members along with members of families showing support for the miners also. These rallies held in many cities across the county sent a loud message to Washington and the members of Congress.

UMWA Band at the Fairmont Armory. The UMWA held a rally several months after the disaster to gain support from rank-and-file members to support safety reforms for miners. The loss of the 78 men who died working to provide a living for their families would not be allowed to go unrecognized by union officials and the family members of those men.

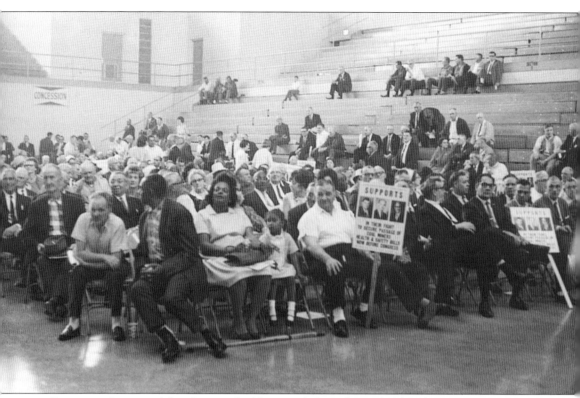

FAIRMONT ARMORY. After the mine had been sealed, a rally was held at the Fairmont Armory to support mine safety reform being lobbied by the UMWA in Washington, DC. During the 1960s, the UMWA had a very powerful lobby in Washington because most of the mines throughout the United States were members of the union. Coal was the basic source used to power the nation's electrical generation plants, and it played a major part in the production of steel. The coal industry was so important during that period in history that without it, a major portion of the country's economy could have been crippled.

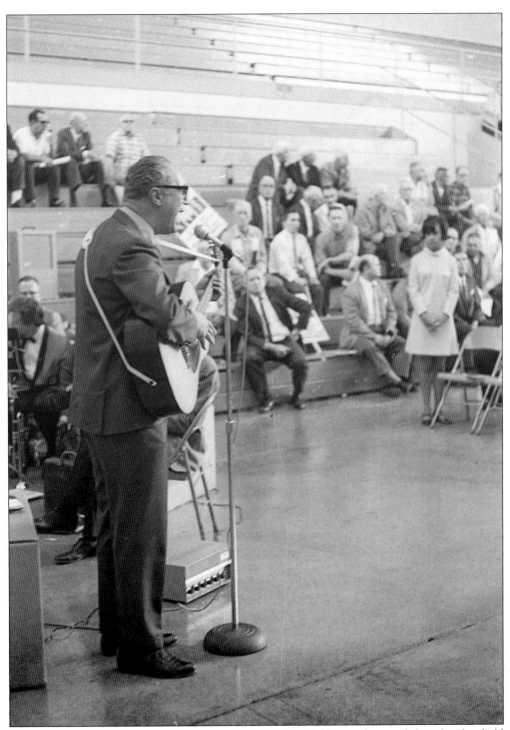

ENTERTAINMENT AT ARMORY. The support of the rank-and-file members and their families held strong influence, showing Washington politicians how important this issue was to the mining community. This grassroots campaigning did play into changing how mining in the country would move forward and improved the working conditions for all miners.

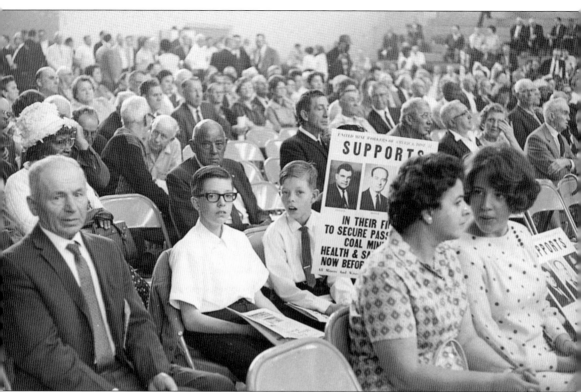

Union Members Support Reform. Pres. Richard Nixon signed the Federal Coal Mine Health and Safety Act on December 30, 1969. US Public Law 91-173, usually called the Coal Act, was passed by the 91st Congress and changed the safety standards for all future coal miners. This legislation created the Mining Enforcement and Safety Administration (MESA), later renamed the Mine Safety and Health Administration (MSHA) within the Department of Labor. This not only covered coal mining underground, but also surface mining as well as all forms of mining within the United States. This Coal Act required that underground mines be inspected four times per year and had the enforcement of the federal government. If mines did not follow required safety practices, monetary penalties would be assessed for violations. The act also established criminal penalties for any knowing and willful violations. Higher standards and procedures were also required to be developed for the safety of the miners working in this profession.

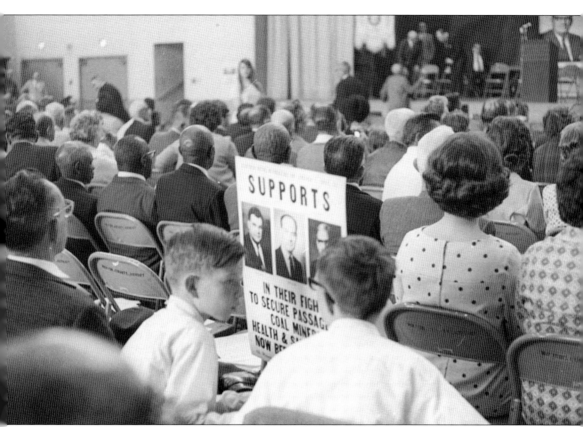

YOUNG SUPPORTERS FOR SAFETY. These two young boys are at a rally at the Fairmont Armory to show support for safety reforms to protect future miners. These boys quite possibly went on to follow in their fathers' footsteps—as so many young men did in West Virginia—and become miners. Their future would be much safer with the passage of a legislative mine safety act.

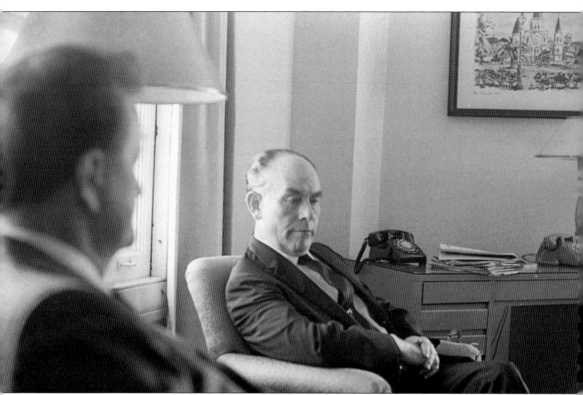

BOYLE'S PRIVATE MEETINGS. UMWA president Tony Boyle is seen here before a meeting at the Fairmont Hotel to muster support from lobbying legislators for mine reform. The union was applying pressure on legislators in Washington, DC, to set higher safety standards for miners and establish safer working conditions in the mines.

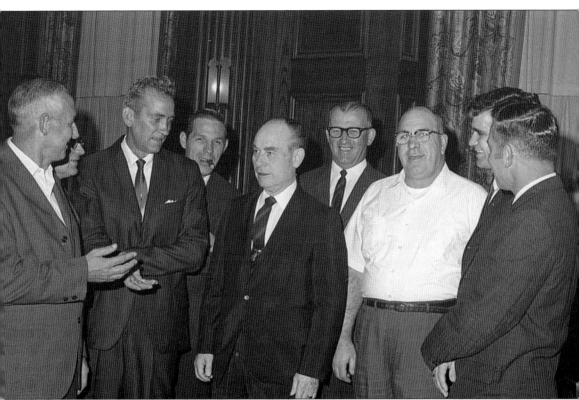

BOYLE (CENTER) TALKING TO UNION SUPPORTERS BEFORE MEETING AT HOTEL. Rank-and-file members of the United Mine Workers of America and union officials have an informal discussion before a meeting at the Fairmont Hotel. These sessions were important to make sure the union had the backing of its members. West Virginia in the 1960s was a very strong union state, and the UMWA was one of the strongest unions of the time.

FAIRMONT HOTEL MEETING WELL ATTENDED. At the UMWA meeting held at the Fairmont Hotel, the union outlined its plan for getting legislators on board to pass legislation to help protect coal miners across the nation. The meeting was well attended, as union leaders and officials presented a very strong agenda to the members and asked rank-and-file affiliates to contact their legislative representatives to show support for stronger laws governing mining in the United States. Meetings like this one were being held across the country where the UMWA had membership, and it was in part due to the union's strong support that legislation was passed backing the coal mining industry.

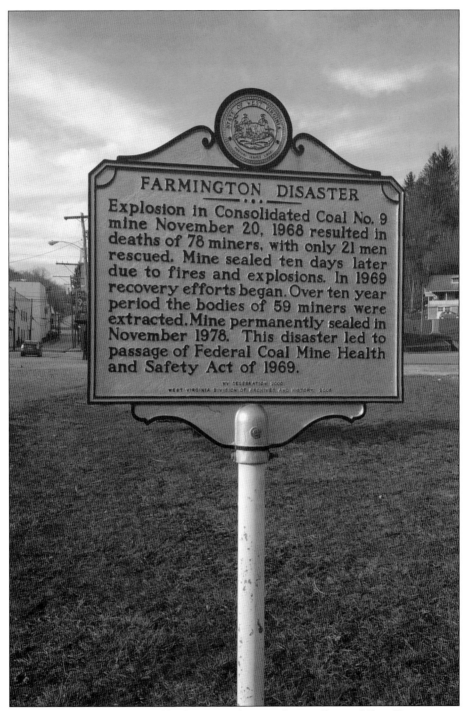

HISTORICAL MARKER. Turning off US Route 250 onto County Route 218 at Farmington, one can see this historical marker in remembrance of the Farmington disaster of 1968. Today, it is a small commemoration to the 78 men who lost their lives 50 years ago. Not much has changed in this small town, but the incident changed the lives for many miners in many ways moving forward after the event.

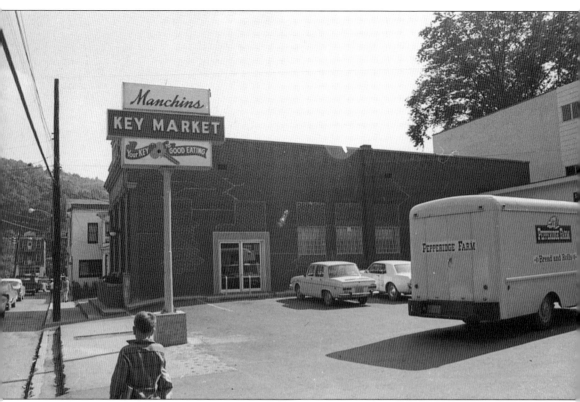

MANCHIN GROCERY STORE. The Champion store was the source of most dry goods and hardware supplies for many of the miners working at the Farmington No. 9 mine, but there was another store located in the heart of the small town of Farmington. The Manchin Key Market was operated by Papa Joe Manchin and his wife, Kay, for many years, and miners and their family members could purchase food products. Many of the families would have a "tick," referred to today as a charge account, a running account of items that were purchased by miners and family members between paydays. During hard times at the mines, the little store would go long periods of time without being paid for merchandise until the miners got back to work.

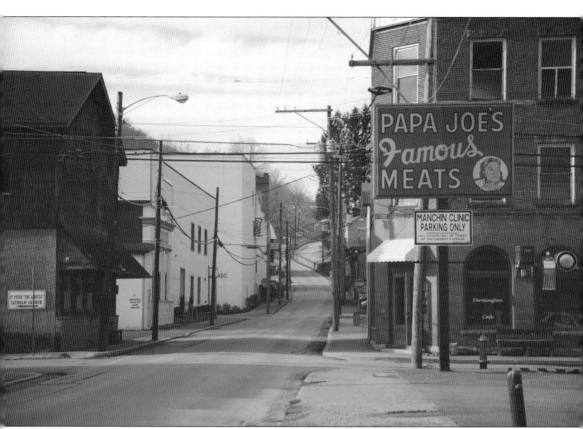

ONLY THE SIGN REMAINS. The store has been torn down and replaced by the Manchin Clinic, but the sign that once proudly advertised the friendly store is a greeting to all who enter Farmington today. In 2016, many residents still speak very fondly of the couple who ran the store and always had compassion for the miners and their families in the small community.

CHAMPION STORE TODAY. About one mile north of the town of Farmington, on West Virginia Route 218, is the site where the Champion store stood and housed family members, friends, and news media for the first four days of the disaster. Today, the building has been converted into a garage, and there are no signs to indicate all the hopefulness and heartbreak felt during those first few days of the 11-day ordeal for family members.

CHAMPION STORE NOW A GARAGE. A once busy store for miners and their families, the Champion store is now a run-down garage. The storefront has been replaced with a large overhead garage door, and there are no visible signs that it once housed a retail operation associated with the Farmington No. 9 mining community. For four days in 1968, it also functioned as press headquarters and a shelter for family members of the 78 trapped miners.

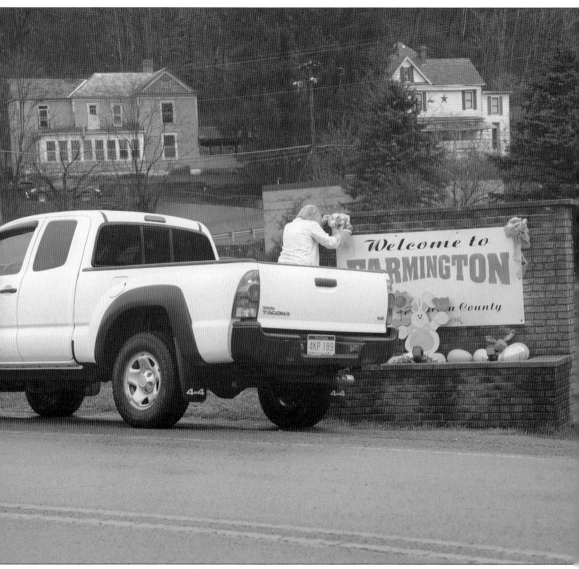

FARMINGTON DECORATIONS. The "Welcome To Farmington" sign is being decorated by members of the city council for Easter in 2015. Although the population of Farmington has dwindled and there are no mines still in operation, the people of the town still shows a great deal of pride in their heritage. One of West Virginia's senators, Joseph Manchin III, was born and raised in this community and to this day still works to preserve the coal industry.

LLEWELLYN PORTAL LOCATION TODAY. The Farmington Mine was closed in 1978 and all aboveground structures were dismantled and the shafts filled in and sealed. The past 35 years have just about erased all signs of the massive mining that took place beneath the surface in this location. However, there is a pump that is still in operation, pumping water from the abandoned mine below to a pond aboveground for environmental protection.

JAMES FORK UNITED METHODIST CHURCH SITE. James Fork United Methodist Church served as a meeting space for the families during the days following the mine disaster. The church stood in the shadow of the main tipple of No. 9, and families found comfort away from the news media and inquisitive bystanders coming into their small community. The church is no longer standing; it was later partially demolished and a house was built around what remained of the church. This photograph shows how much has changed over nearly five decades.

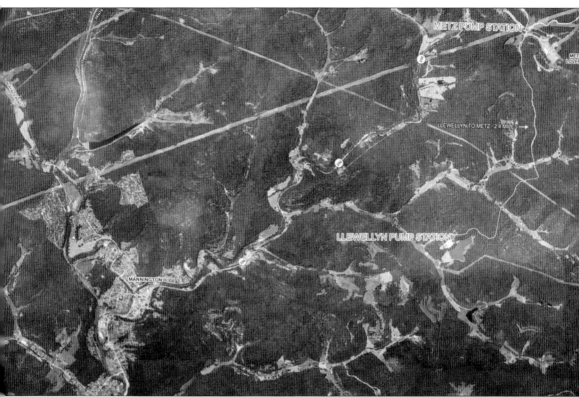

AERIAL VIEW OF MANNINGTON AND FARMINGTON. A large aerial map hangs in the former office of the Consolidation Coal Company at Monongah, West Virginia. The office is now a part of Murry Energy Corporation, which purchased Consol's five large underground coal mines in northern West Virginia in December 2013 for a price of $3.5 billion.

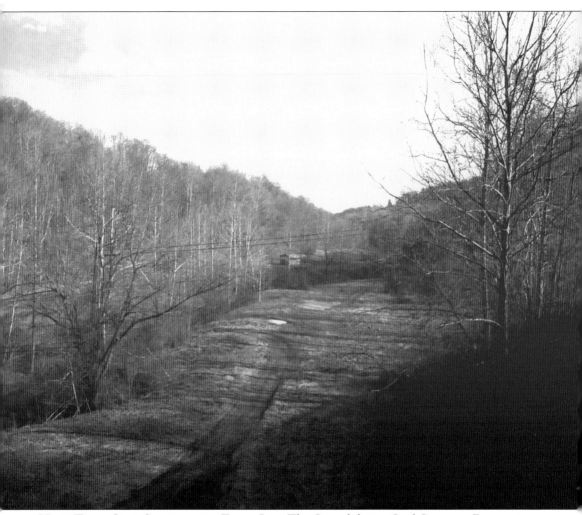

No. 9 Tipple Once Stood on the Empty Lot. The Consolidation Coal Company Farmington No. 9 mine main preparation plant once filled this vacant lot and railcars carried out tons of coal on a daily basis. Once the decision to close the mine in 1978 was made, all visible signs of the mine were dismantled. The humming of the large machinery, which processed the coal and echoed through this valley, can no longer be heard. With no traffic traveling on the highway, one can hear the ripple of the small James Creek that passes alongside the vacant land.

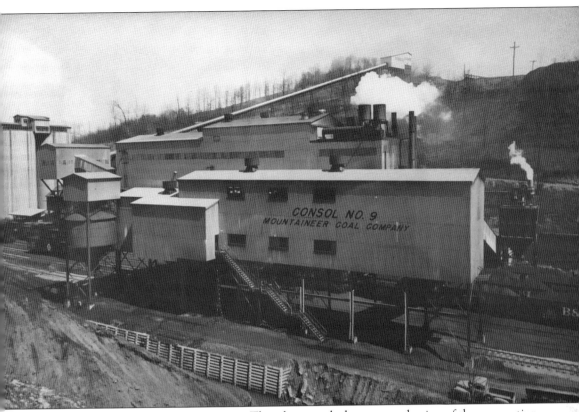

MOUNTAINEER COAL COMPANY TIPPLE. This photograph shows an early view of the preparation plant, or tipple, at Farmington, possibly taken in the early 1960s, years before the explosion. This was taken at a time when coal was king and mining in West Virginia was the number one business for the state. Farmington No. 9 mine produced on average 10,000 tons of coal per day. Typically, the mine operated five days a week, three shifts—day, afternoon, and cateye (midnight). During this period of time, it was common for the mine to sometimes operate on weekends, when the demand for coal was high.

MINE FIRE OR EXPLOSION POSTER. This poster hanging at the office complex in Monongah is typical of those that are posted at every mine that was owned by Consol. It warns of the hazards of fires and explosions and provides steps the miners should take to prevent them from happening. The speculation is that none of these human factors caused the explosion at the Farmington No. 9 mine in 1968. It was more than likely a spark caused by the mining machinery cutting into the coal ignited the methane gas.

Janet Lieving Inscription on Back of Artwork. Janet Lieving worked for Consolidation Coal Corporation and is now employed by Murry Energy Corporation at the Monongah office for Mountaineer Coal Division. The inscription on the back of the artist's drawing reads, "To, Eugene Lieving 'Dad and Poppy' – In your honor and service to the mines. From Scott, Janet, Ryan, and Mathew." Eugene Lieving was Janet's father-in-law and at the time of the disaster was manager of safety at the mine.

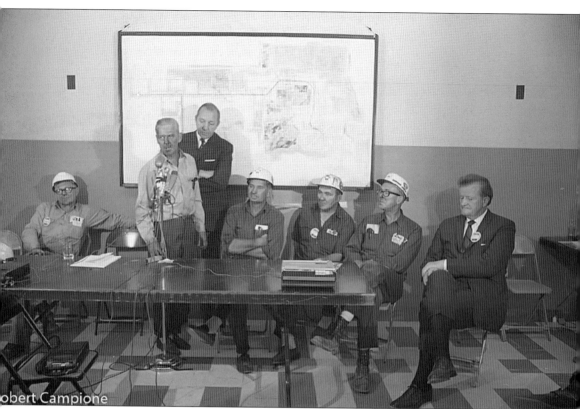

EUGENE LIEVING. As an employee for Mountaineer Coal Division of the Consolidation Coal Company, Eugene Lieving (second from right) was the mine safety inspector for No. 9 and was responsible for overseeing the ventilation within the mine. Ventilation in a coal mine is extremely critical to mine operations; fresh air enters from the surface through an air shaft running into the mine. Large fans at the surface force air down the shaft and into the mine, where it is distributed to areas the miners are working in. In the event there is a loss of ventilation for any reason, the miners are to take certain precautions, including exiting the mine until ventilation can be restored.

AUTOGRAPHS OF TWO OF THE MINERS. Two of the three men to come out of the Farmington No. 9 mine in a construction bucket signed an artist's drawing of a photograph that shows them just before they were lifted to safety. Janet Lieving purchased the drawing and presented it to her father-in-law, Eugene Lieving.

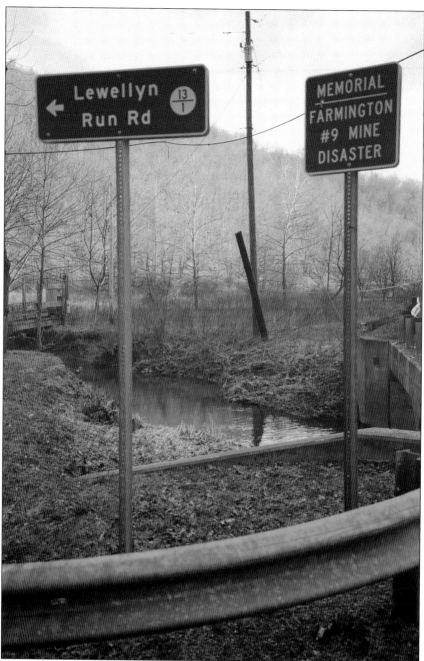

THE FARMINGTON NO. 9 MONUMENT ROAD SIGNS. A monument was erected on Lewellyn Run about one mile from the actual location of the mine shaft. Lewellyn Run is located roughly one mile north of Mannington, West Virginia, just off US Route 250. The night of November 19, 1968, miners on the cateye shift traveled this route, making a turn onto Flat Run and driving about a mile before reaching Lewellyn Run and turning to go up the narrow road. Just up the narrow road were the bathhouse and the elevator that would take them into the mine for their eight-hour shift. Little did any of these men know it would be the last time the majority of them would ever make this trip.

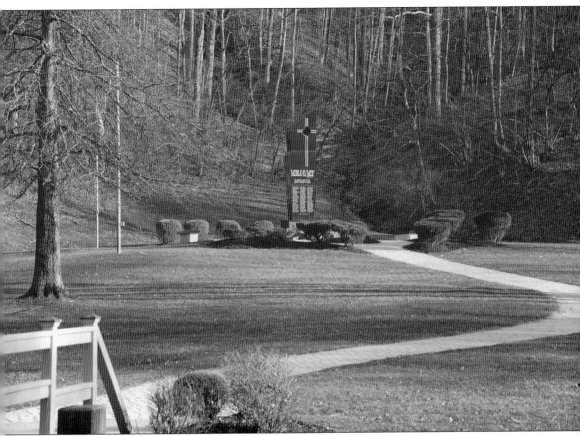

THE PATH. The twisting pathway leading to the monument symbolizes how these men traveled the twisted back roads of West Virginia to get to the mine. When entering the property, one gets the sense of peace and tranquility because there are only the sounds of the wind, birds, and a trickling stream running alongside the entry up to the monument. This is very much unlike the chaos those miners experienced on the cateye shift in the early morning hours of November 20, 1968. Those who survived the initial blast must have felt the earth shake and realized they must make their way out of the black silence when the electrical power in the mine died and all became silent. Twenty-one miners would make their way to safety that morning, but 78 of them would never see the light of day again. The bodies of 19 miners were never recovered from the mine, and this monument now represents a common grave marker for those brave men.

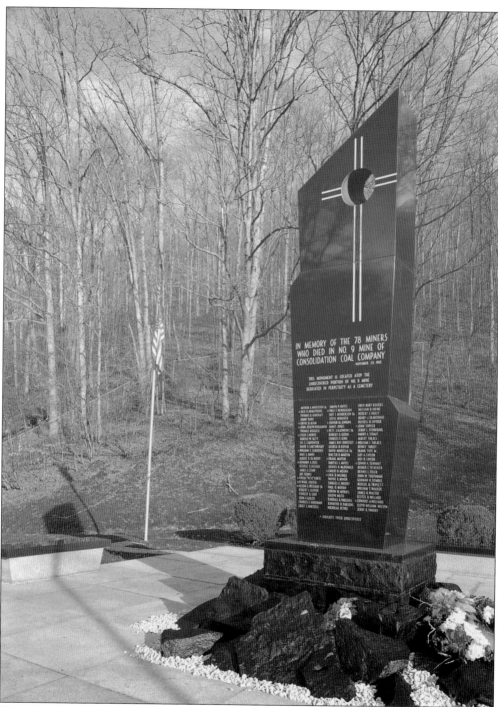

Monument Stands Tall. The black granite monument stands tall in quiet desolation, as did the miners who worked beneath it more than 40 years ago. It is a reminder of those miners who stood tall every day they worked underground to mine coal to support the nation's industries. Without these miners, the United States may not have been the industrial power it became. Coal fired the nation's power plants and helped produce the steel used in many applications.

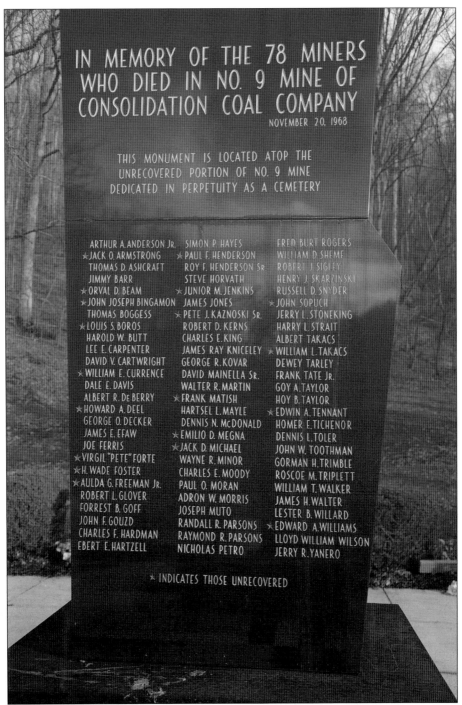

Monument Close-Up. Walking up to the monument and seeing the names of the 78 miners inscribed on the black granite sends chills through the body. It is hard to imagine what they must have gone through that early November morning. Their lives ended so abruptly, but the memories live on with the families that were left behind. Many of the widows have also passed on, but the children will tell the story of how their fathers perished and helped reform the industry.

WREATH AT MONUMENT. Murry Energy Corporation purchased the Consolidation Coal Company mines, but it continues to commemorate the 78 miners who perished nearly 50 years ago. Placing a wreath at the foot of the monument, the company honors those men and the sacrifice they made.

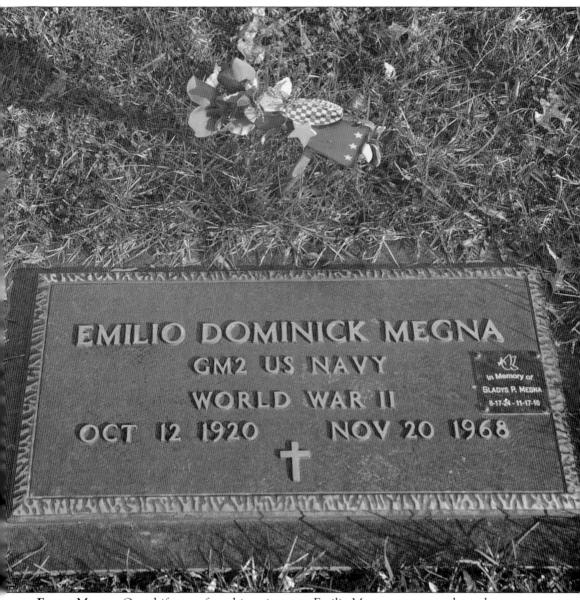

EMILIO MEGNA. One shift away from his retirement, Emilio Megna went to work on the cateye shift on November 19, 1968. The cateye shift would conclude at about 7:00 a.m. the next morning, and Megna would be free to do the things he had always wanted to do. He, along with 77 other miners, would not see the shift end, and his body, along with 18 others, was never recovered from the mine. The bronze military marker at the foot of the Farmington No. 9 memorial is a reminder of those 19 bodies still entombed 600 feet underground. Their shift ended way too abruptly.

W.F. JONES FUNERAL HOME IN MANNINGTON. The W.F. Jones Funeral Home was where recovered bodies were brought for identification. R.D Patterson, a Consol representative, along with Dr. Coon, Marion County coroner, used the garage area of the funeral home, set up as a temporary morgue, to identify the remains. Once positive identification was made, Patterson would personally visit each widow or family to let them know the body was recovered.

Miners Lost to the 1968 Farmington Mine Disaster

Arthur A. Anderson Jr.
*Jack O. Armstrong
Thomas D. Ashcraft
Jimmy Barr
*Orval D. Beam
*John Joseph Bingamon
Thomas Boggess
*Louis S. Boros
Harold W. Butt
Lee E. Carpenter
David V. Cartwright
*William E. Currence
Dale E. Davis
Albert R. DeBerry
*Howard A. Deel
George O. Decker
James E. Efaw
Joe Ferris
*Virgil A. "Pete" Forte
*Hilery Wade Foster
*Aulda G. Freeman Jr.
Robert L. Glover
Forrest B. Goff
John F. Gouzd
Charles F. Hardman
Ebert E. Hartzell
Simon P. Hayes
*Paul F. Henderson
Roy F. Henderson Sr.
Steve Horvath
*Junior M. Jenkins
James Jones
*Pete J. Kaznoski Sr.
Robert D. Kerns
Charles E. King
James Ray Kniceley
George R. Kovar
David Mainell Sr.
Walter R. Martin
*Frank Matish

Hartsel L. Mayle
Dennis N. McDonald
*Emilio D. Megna
*Jack D. Michael
Wayne R. Minor
Charles E. Moody
Paul O. Moran
Adron W. Morris
Joseph Muto
Randall R. Parsons
Raymond R. Parsons
Nicholas Petro
Fred Burt Rogers
William D. Sheme
Robert J. Sigley
Henry J. Skarzinski
Russell D. Snyder
*John Sopuch
Jerry L. Stoneking
Harry L. Strait
Albert Takacs
*William L. Takacs
Dewey Tarley
Frank Tate Jr.
Goy A. Taylor
Hoy B. Taylor
*Edwin A. Tennant
Homer E. Tichenor
Dennis L. Toler
John W. Toothman
Gorman H. Trimble
Roscoe M. Triplett
William T. Walker
James H. Walters
Lester B. Willard
*Edward A. Williams
Lloyd William Wilson
Jerry R. Yanero

*Unrecovered

Survivors of the 1968 Farmington Mine Disaster

Roy Wilson
George Wilson
Alvie Davis
Lewis Lake
Ralph Starkey
Gary Martin
Charlie Crim
Neezer Vandergrift
Raymond Parker
Robert Mullins
James Herron
Paul Sabo
Nick Kose
Robert Bland
Bud Hillberry
Nathaniel Stevens
Walter Slavekosky
Charles Beafore
Byron Jones
Henry Conaway
Matt Menas Jr.

"The Mannington Mine Disaster"

We read in the paper and the radio tells
Us to raise our children to be miners as well.
Oh tell them how safe the mines are today
And to be like your daddy, bring home a big pay.

Now don't you believe them, my boy,
That story's a lie.
Remember the disaster at the Mannington mine
Where seventy-eight miners were buried alive,
Because of unsafe conditions your daddy died.

They lure us with money, it sure is a sight.
When you may never live to see the daylight
With your name among the big headlines
Like that awful disaster at the Mannington mine.

So don't you believe them, my boy,
That story's a lie.
Remember the disaster at the Mannington mine
Where seventy-eight miners were buried alive,
Because of unsafe conditions your daddy died.

There's a man in a big house way up on the hill
Far, far from the shacks where the poor miners live.
He's got plenty of money, Lord, everything's fine
And he has forgotten the Mannington mine.
Yes, he has forgotten the Mannington mine.
There is a grave way down in the Mannington mine
There is a grave way down in the Mannington mine.
Oh, what were their last thoughts, what were their cries
As the flames overtook them in the Mannington mine.

So don't you believe them, my boy,
That story's a lie.
Remember the disaster at the Mannington mine
Where seventy-eight good men so uselessly died
Oh, don't follow your daddy to the Mannington mine.

How can God forgive you, you do know what you've done.
You've killed my husband, now you want my son.

—Hazel Dickens, 1970

Discover Thousands of Local History Books Featuring Millions of Vintage Images

Arcadia Publishing, the leading local history publisher in the United States, is committed to making history accessible and meaningful through publishing books that celebrate and preserve the heritage of America's people and places.

Find more books like this at
www.arcadiapublishing.com

Search for your hometown history, your old stomping grounds, and even your favorite sports team.

Consistent with our mission to preserve history on a local level, this book was printed in South Carolina on American-made paper and manufactured entirely in the United States. Products carrying the accredited Forest Stewardship Council (FSC) label are printed on 100 percent FSC-certified paper.